San Diego's
Balboa Park

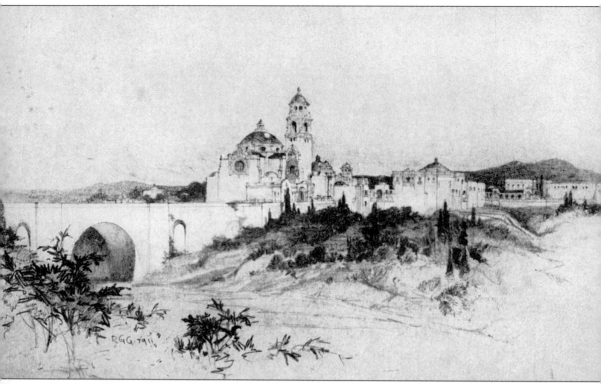

ICONIC VIEW, 1911. This picturesque drawing of the Cabrillo Bridge and California Building is from an early promotional postcard. The artist's signature "B.G.G. 1911" at the lower left refers to exposition architect Bertram Grosvenor Goodhue. Note that this early design shows the bridge with fewer arches and the tower with one less tier. (David Marshall, postcard collection.)

ON THE COVER: This view of the Plaza de Panama in 1915 looks southwest during the Panama–California Exposition. The plaza was the center of activity during the exposition. The American flag has 48 stars, including those for New Mexico and Arizona, both given statehood only three years before this photograph was taken. (David Marshall, postcard collection.)

POSTCARD HISTORY SERIES

San Diego's Balboa Park

David Marshall, AIA

ARCADIA
PUBLISHING

Copyright © 2007 by David Marshall
ISBN 978-0-7385-4754-1

Published by Arcadia Publishing
Charleston SC, Chicago IL, Portsmouth NH, San Francisco CA

Printed in the United States of America

Library of Congress Catalog Card Number: 2007920166

For all general information contact Arcadia Publishing at:
Telephone 843-853-2070
Fax 843-853-0044
E-mail sales@arcadiapublishing.com
For customer service and orders:
Toll-Free 1-888-313-2665

Visit us on the Internet at www.arcadiapublishing.com

This book is dedicated to my wife (and proofreader), Stacy, our son Ryan, my parents, my friends and colleagues at Heritage Architecture and Planning, and all the people who have fought to keep Balboa Park a beautiful urban oasis.

CONTENTS

ACKNOWLEDGMENTS

Special thanks to Milford Wayne Donaldson, for inspiring my interest in preservation architecture and infecting me with his postcard-collecting virus. Also thanks to Michael Kelly, M.D., and William Chandler, who provided essential feedback and volunteered their historical knowledge to this endeavor.

I would also like to thank the Save Our Heritage Organisation (SOHO), the San Diego Historical Resources Board, the San Diego Architectural Foundation, the San Diego Park and Recreation Department, Friends of Balboa Park, and The Committee of One Hundred for their dedication to protecting and preserving Balboa Park's amazing architectural heritage.

And finally, special thanks to the San Diego Historical Society whose easy-to-navigate Web site contains massive amounts of invaluable information about San Diego and, especially, Balboa Park.

All images used in this book come from the author's private collection.

INTRODUCTION

You can cross the great bridge and find yourself in another world.

—George W. Marston, 1922

There truly is no other place like San Diego's Balboa Park. Other great urban parks, like New York's Central Park and San Francisco's Golden Gate Park, are traditional parks dominated by open space and the beauty of nature. But Balboa Park is much more. Aside from the natural splendor of towering Eucalyptus trees, great lawns, and vivid floral displays, Balboa Park is about architecture as well as nature. Nowhere else does an urban park of this scale have such a combination of natural and man-made beauty.

Balboa Park began when San Diego's civic leaders created a 1,400-acre City Park in 1868. In 1910, a contest to rename the park resulted in the selection of "Balboa Park," after Spanish explorer Vasco Nunez de Balboa who, in 1513, was the first European to see the Pacific Ocean.

Early Balboa Park was not the horticultural wonderland that it is today. It was dotted with natural canyons and mesas that were covered in dense chaparral, wild flowers, and sagebrush. The park saw few visitors other than coyotes, wildcats, rabbits, quail, and lizards.

The watershed moment for Balboa Park came in 1915–1916 when San Diego held the Panama-California Exposition to celebrate the completion of the Panama Canal. San Diego's boosters wanted the world to know that their large, natural bay would be the closest American Pacific Coast port to Panama. In 1909, when the city's desire to host the exposition was announced, San Diego's population of 39,000 was the smallest of any city to ever attempt an international exposition.

San Diego had to overcome many struggles to bring the fair to fruition, including competition from New Orleans and San Francisco, each intending to host similar expositions to celebrate the Panama Canal. In 1911, the U.S. Congress voted to support the San Francisco exposition in what some thought would be a fatal blow to San Diego's ambitions. Undeterred, planning for the Balboa Park exposition proceeded, and the organizers hired New York's Bertram Goodhue as the exposition's lead architect. Goodhue's plans for the buildings in Balboa Park differed dramatically from previous exposition tradition. Rather than using the accepted style of Beaux-Arts, classical Greek, or Roman (which was the style of Chicago's famed "White City" and San Francisco's competing exposition), Goodhue designed his buildings in the exotic Spanish Colonial Revival style.

Bertram Goodhue described his vision as "a city-in-miniature wherein everything that met the eye and ear of the visitor were meant to recall . . . the glamour and mystery and poetry of the old Spanish Days." He also spoke about the relevance of the Spanish style to San Diego by writing, "A new city of Old Spain not only would be in closer harmony with the beauties of Southern California but also would be a distinct step forward in American Architecture."

The Panama-California Exposition opened in Balboa Park on January 1, 1915. Somewhat defensively, the official *Guide Book* declared that San Diego's event was "not the largest world's fair ever held, but the most interesting, as well as the most beautiful." The park quickly became known for its sculptured fantasy buildings, which helped to popularize the Spanish Colonial Revival style for many decades to follow. Icons like the California Tower and the Botanical Building became symbols not just of the park, but also of the entire region.

The exposition was a huge success and was extended for a second year. San Diego's 1915–1916 event attracted 3.8 million visitors over 24 months. A *San Diego Union* editorial in 1916 suggested that the success of the 1915 exposition "proclaims to the world that a great future awaits San Diego and that its progressiveness may at any time be looked of to make history."

After the success of the 1915 exposition, the evolution of the park included occupation by the U.S. Navy who created a naval training station during World War I. After the navy left, George W. Marston, the "Father of Balboa Park," spoke out to save the exposition buildings. In a 1922 letter to the *San Diego Union* he wrote, "Why should the park buildings be saved? . . . the community has grown slowly into conviction that what we have there in the park—which is something more than mere buildings—must not perish. Somehow, without knowing how to explain it, we are instinctively, unconsciously, incurably in love with them and will not give them up."

Balboa Park's second big event came in 1935 when it hosted yet another world's fair. The 1935–1936 California Pacific International Exposition was intended to promote the city and cure San Diego's post-Depression ills. Balboa Park was reconfigured by San Diego architect Richard S. Requa who also oversaw the design and construction of many new buildings. The second exposition left behind a legacy of colorful stories with its odd and controversial exhibits and sideshow entertainment. "America's Exposition" also provided visitors with early glimpses of a walking silver robot and a strange electrical device known as a "television."

Like the first exposition, the 1935 fair was so successful it was extended for a second year. Opening ceremonies for the second season began when Pres. Franklin D. Roosevelt pressed a gold telegraph key in the White House to turn on the exposition's lights. When the final numbers were tallied, the 1935–1936 event counted 6.7 million visitors—almost double the total of the 1915–1916 exposition. The buildings from both expositions now make up a National Historic Landmark District, which is perhaps the most intact exposition site remaining anywhere in the nation.

In the years since 1936, San Diegans have been faced with choices about whether more and bigger buildings are in the best interests of Balboa Park. More than 80 years ago, George Marston said, "Balboa Park is primarily a park. . . . The building of hospitals and schoolhouses, libraries and museums, must cease, or else we shall have a city there instead of a park."

Balboa Park contains one of the largest collections of museums and attractions outside the Smithsonian Institute in Washington, D.C., and has become the largest urban cultural park in the nation. Clearly Balboa Park is a *place* more than just a collection of buildings, fountains, and trees. Many great men and women helped create San Diego's romantic Spanish city on the hill, and their splendid vision is what still brings over 10 million visitors to Balboa Park every year.

ABOUT THIS BOOK

For the creation of this postcard history of Balboa Park, every effort was made to reference primary sources. Original publications, such as exposition guide books, programs, brochures, and other historical data were consulted throughout the research process. Words in quotations were taken directly from a historical source.

The following postcard images of Balboa Park offer the reader a novel look at San Diego's cultural and recreational heart. I hope that everyone enjoys this postcard compilation and takes away a better understanding of how present-day Balboa Park came to be. Few locations in the world can claim a history as rich, unique, and varied as San Diego's Balboa Park.

One

PLANNING A WORLD'S FAIR

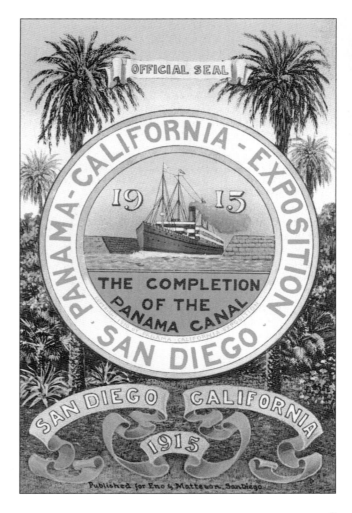

OFFICIAL SEAL. The seal of the Panama-California Exposition depicts a ship passing through the Panama Canal. The ship was the cargo vessel SS *Ancon*, which was the first to navigate the passage. The canal formally opened on August 15, 1914. This seal is printed on the back of many of the exposition postcards.

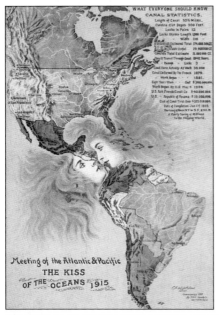

THE KISS OF THE OCEANS. This 1910 postcard was actually created to promote San Francisco's competing Panama–Pacific International Exposition. Note how the text for San Francisco is significantly larger than the text for San Diego. The statistics at the upper right note that the route between New York and San Francisco would be shortened by 8,415 miles once the Panama Canal is completed.

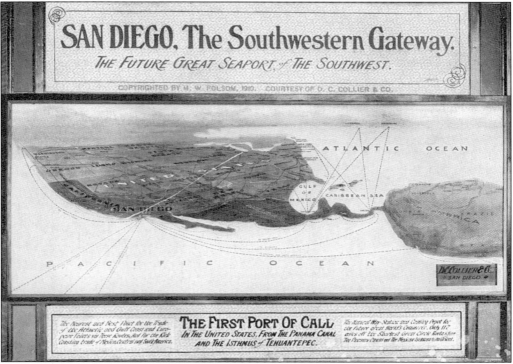

FIRST PORT OF CALL. This is one of a series of early exposition postcards promoting San Diego as a great seaport with a beautiful bay. Note that rival San Francisco is virtually invisible on the map, and that the rail route from Chicago to Los Angeles is strongly emphasized. The small print at the bottom concludes by stating that San Diego bay is "only 117 miles off the shortest great circle routes from the Panama Canal and the Mexican Isthmus to the Orient."

ADMINISTRATION BUILDING. Published in 1912, this illustration shows an early design for the Administration Building at the west end of the exposition grounds. The seal on this postcard is unique because it alludes to San Francisco's competing exposition with its reference to "California the Exposition State." The fountain in the foreground was never constructed.

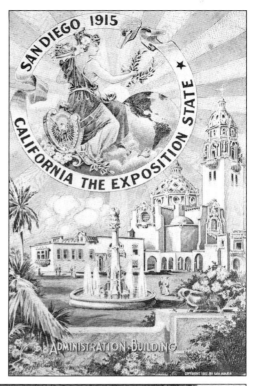

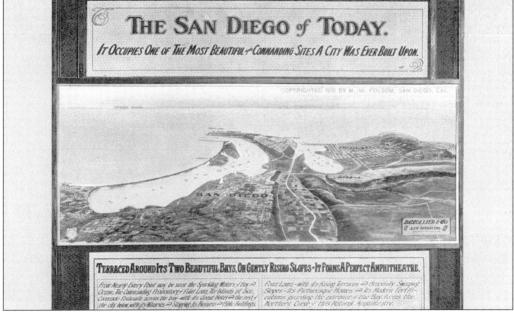

THE SAN DIEGO OF TODAY. This bird's-eye view of San Diego promotes its "two beautiful bays" ringed by rising slopes forming "a perfect amphitheatre." Also noted are the "modern fortifications guarding the entrance of the bay." The publisher of this card, and many others like it, was San Diego developer D. C. Collier. Collier also served as a director for the exposition.

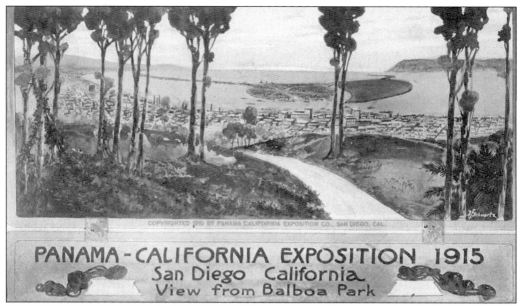

PANAMA-CALIFORNIA EXPOSITION 1915
San Diego California
View from Balboa Park

VIEW FROM BALBOA PARK. This 1910 illustration shows the relationship of the Balboa Park exposition grounds to downtown, the bay, and Coronado Island. Note the stylized eucalyptus trees in the foreground. Famed horticulturalist Kate O. Sessions once operated a 10-acre nursery in the northwest corner of Balboa Park beginning in 1892. Sessions is credited with importing and planting Balboa Park's first eucalyptus trees.

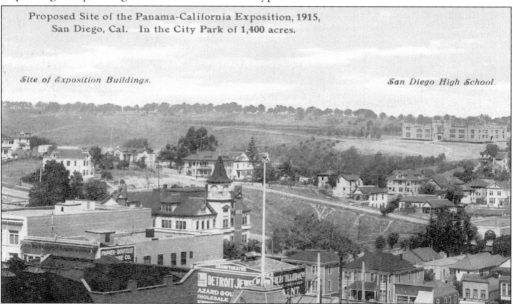

Proposed Site of the Panama-California Exposition, 1915,
San Diego, Cal. In the City Park of 1,400 acres.

Site of Exposition Buildings.

San Diego High School.

PROPOSED SITE. This postcard shows pre-exposition City Park from downtown, looking northeast. The park was officially rechristened Balboa Park after Spanish explorer Vasco Nunez de Balboa in 1909. The southern end of Balboa Park was the site chosen by landscape architects John C. and Frederick Law Olmsted Jr., because of its proximity to downtown. The eventual decision to locate the exposition on the Central Mesa led to the resignation of the Olmsted brothers.

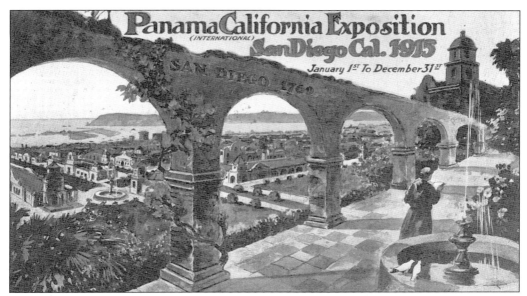

"INTERNATIONAL" EXPOSITION. This 1910 rendering shows the exposition grounds filled with buildings and plazas designed in the Mission style. This is prior to the adoption of the more dramatic Spanish Colonial Revival style. Note the italicized "International" in the title. The name Panama–California *International* Exposition was not used until the second year of the exposition, after San Francisco's competing exposition had ended.

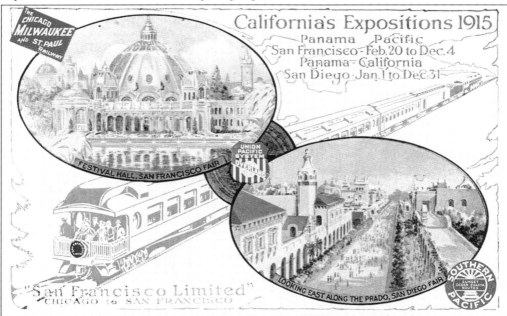

CALIFORNIA'S EXPOSITIONS. The railroad companies had much to gain by promoting California's two world expositions. This postcard was sponsored by three different railways to entice easterners to the Golden State in 1915. It was very rare for a postcard to feature both the San Diego and San Francisco expositions. Southern Pacific Railway offered a round-trip fare between the two expositions for $22.75.

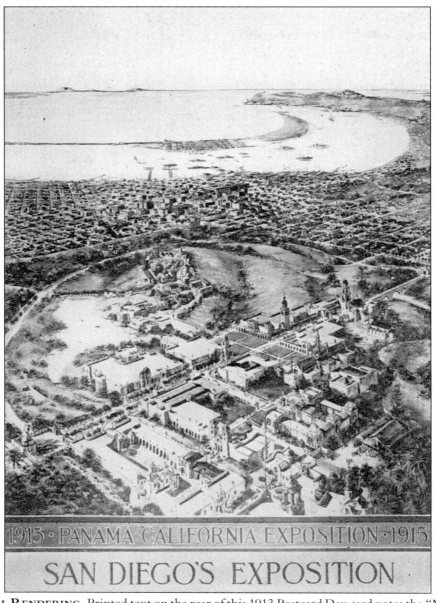

1915 · PANAMA CALIFORNIA EXPOSITION · 1915

SAN DIEGO'S EXPOSITION ·

AERIAL RENDERING. Printed text on the rear of this 1913 Postcard Day card notes the "Mission style of architecture" shown in the illustration. Of course, the eventual style of the exposition was Spanish Colonial Revival rather than Mission. While most of the buildings were never built as shown here, one can pick out the California Building and tower near the Cabrillo Bridge, and the two towers and chapel in front of the Varied Industries Building (Casa del Prado) near the bottom center. Note the many tall towers, the absence of the Organ Pavilion, and the large lake at the center left (white area). The lake was a remnant from the Olmsted brothers' abandoned plan, which was never constructed. Downtown, Coronado Island, and Point Loma can also be seen in this illustration. These "Postcard Day" cards were printed for a mass mailing held on March 17, 1913. Some 50,000 postcards were sent by the State Societies of San Diego in an effort to boost the profile of the city and the exposition.

14

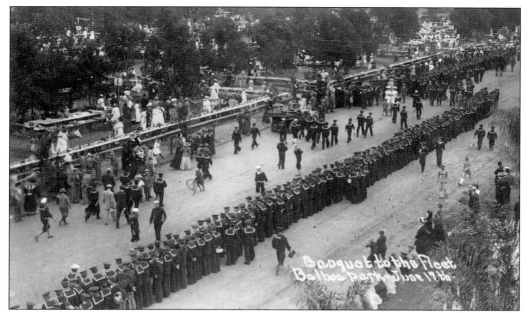

BANQUET TO THE FLEET. This banquet was held on June 17, 1911. The handwritten message on the back of this postcard reads: "The City gave this banquet to sailors and soldiers. Spent ten thousand dollars. Three thousand sat down at the tables." This event took place in Balboa Park one month before the formal ground-breaking celebrations.

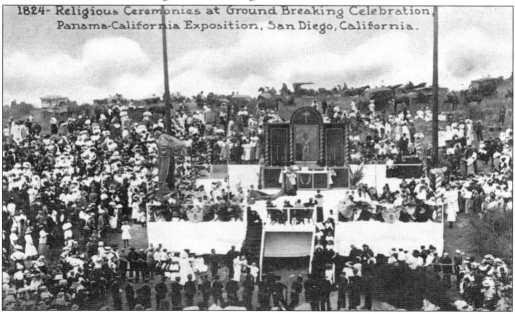

GROUND-BREAKING CELEBRATIONS. The ground-breaking celebrations for the Panama-California Exposition took place between July 19 and 22, 1911. The event was also known as the "San Diego Pageant." Religious ceremonies began the first day of celebrations at this temporary altar in a shallow canyon after the procession walked to the park from St. Joseph's Church at Fourth and Beech Streets.

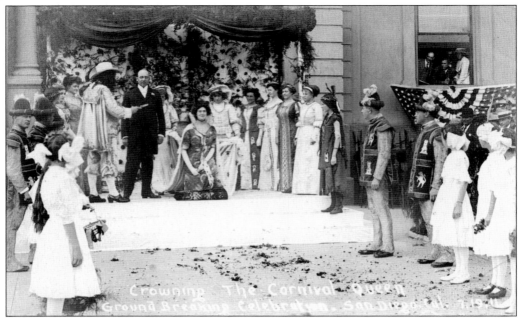

CARNIVAL QUEEN AND KING. The ground-breaking celebrations included much pageantry and drama. The top postcard shows the carnival queen Ramona, played by a woman named Helene Richards. This pretend queen was named for the fictional half–Native American lead character in Helen Hunt Jackson's popular novel *Ramona*. In the bottom postcard, King Cabrillo, played by Morley Stayton, was based on a real person—Portuguese explorer Juan Rodriguez Cabrillo, who was the first European to navigate the coast of California, landing in San Diego in 1542. This photograph was taken downtown near the Floral Parade route. King Cabrillo came ashore at the foot of "D" Street (renamed Broadway in 1915). While the king appears excited about his return to San Diego, members of his court show less enthusiasm.

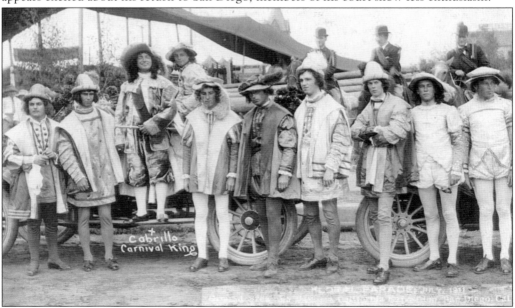

ARCHITECTURAL RENDERINGS. Two more Postcard Day cards are shown here. Printed text on the rear of the card at right notes that "work on the buildings and grounds is now more than fifty per cent completed." The renderings illustrate early versions of several of the exposition buildings, although some are identified with names that were never utilized. Curiously the drawing of the Home Economy Building in the postcard at right is a different view of the same building referred to as the Electricity Building in the bottom postcard. It appears that this was done because not enough designs were available in time for the printing deadline.

NEW METROPOLIS, 1912. This image shows one panel from a foldout postcard published by the Chamber of Commerce of San Diego County. One panel refers to San Diego as "the New Metropolis of the Pacific Coast." Among the boasts, "Ninety thousand population, 54 churches, 11 banks, three daily newspapers, and only three days in the year without sunshine."

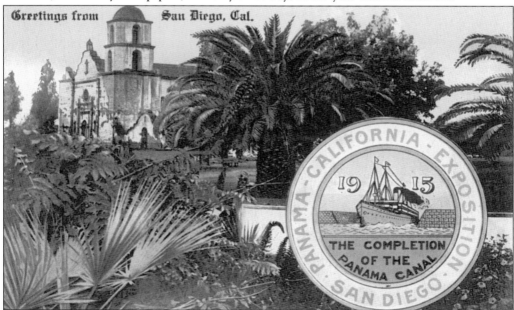

GREETINGS FROM SAN DIEGO. The official seal of the Panama-California Exposition was emblazoned on thousands of postcards between 1910 and 1915. Even postcards showing images of other California cities were branded with the exposition seal on their reverse side. This "Greetings from San Diego" postcard features Mission San Luis Rey in Oceanside—not quite San Diego, but close enough.

Two

FANTASY SPANISH CITY

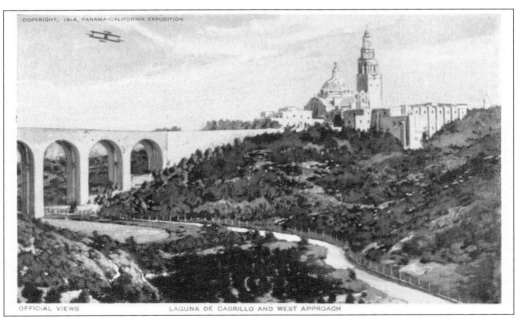

ICONIC VIEW. Prior to the completion of the exposition buildings, artists portrayed how the fair might look when completed. This *c.* 1914 rendering is a close approximation, although the airplane was the artist's fabrication. A small, man-made lagoon ("Laguna de Cabrillo") was created at the base of the bridge to heighten the drama of the approach to the fairgrounds.

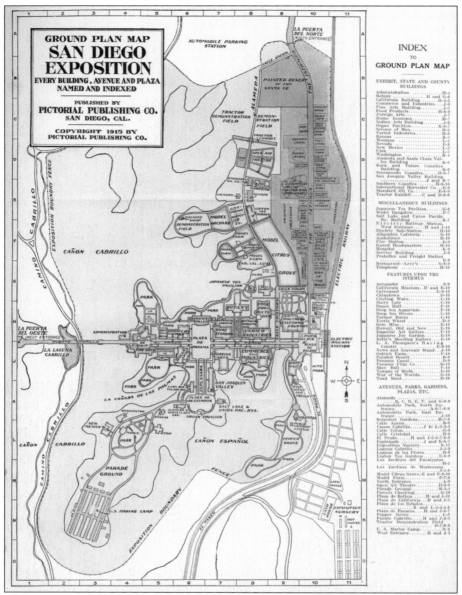

EXPOSITION MAP, 1915. This foldout map is from the booklet *The Exposition Beautiful—Over One Hundred Views*. The map shows the strong east-west axis of El Prado with the Plaza de Panama at the center. The west entrance crosses over the Puente Cabrillo, as it does to this day. The southern Esplanade creates a secondary axis that terminates at the Spreckels Organ Pavilion. The state buildings were primarily located in the southwest area, arranged along less-formal circular pathways. At the far south end, note the Parade Ground and U.S. Marine Camp where the Ford Building (Air and Space Museum) and Palisades area are now located. North of El Prado is the Model Farm, agricultural Demonstration Field, Isthmus fun zone, and Painted Desert exhibit. Note the electric railway tracks and station to the east where Park Boulevard is now located. San Diego once had an extensive network of electric streetcars, which provided convenient access to the exposition. The last of San Diego's streetcars disappeared in 1949.

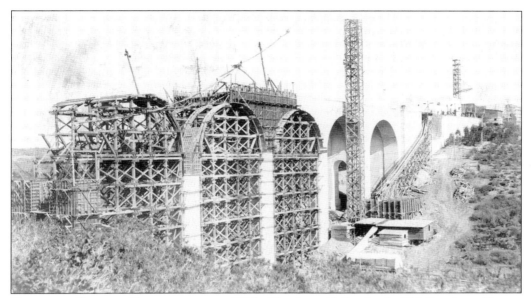

CABRILLO BRIDGE CONSTRUCTION, 1913. The beautifully simple 916-foot-long Puente Cabrillo was designed and engineered by exposition director of works Frank P. Allen Jr. and was modeled after a Roman aqueduct. The bridge incorporates 270,000 cubic feet of concrete—despite being hollow. Postcards rarely depict the construction process, but this card showed that progress was being made. Note the simultaneous construction of the California Building, at the upper right.

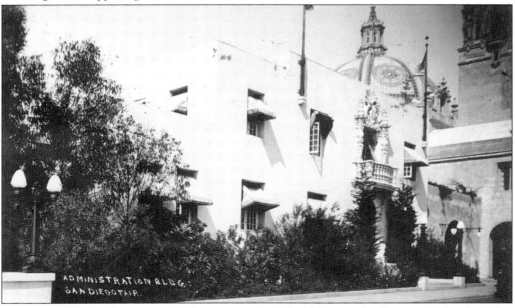

ADMINISTRATION BUILDING. This structure, built in 1911, was the first exposition building constructed. It provided offices for exposition management and the park commission. The theory that famed architect Irving Gill designed the Administration Building was wrongly based on its Gill-esque cubist shape prior to the addition of the ornamentation in 1914. The ornate entrance was removed in the 1950s, but there are plans to have it reconstructed.

21

BIRD'S EYE. This aerial view shows the extent of the exposition grounds. Note the lack of development in most of the park. The large, boxy structure at the upper right was the War of the Worlds building in the Isthmus fun zone area. The many tents of the 4th Marine Regiment 2nd Battalion can be seen at right center. The marines were under the command of Col. Joseph H. Pendleton.

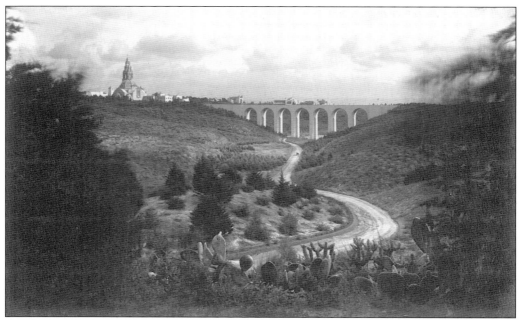

CABRILLO CANYON. This view looking southeast shows the slopes of Cabrillo Canyon and the bridge that shares its name. The Cabrillo Bridge reaches a height of 120 feet above the canyon floor. The bridge remains a beloved city landmark and was restored in 2006. The small dirt road later became State Route 163. Also note the variety of cactus in the foreground.

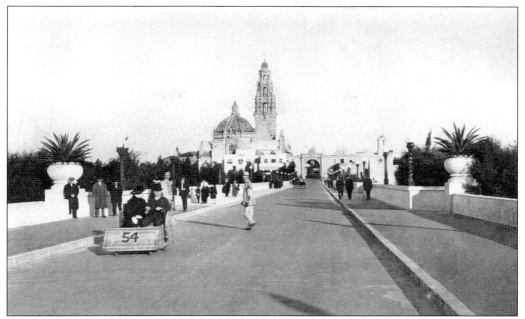

WEST APPROACH. This is the view that visitors to the 1915 Panama-California Exposition had as they passed through the west gate. The tower and dome of the California Building create a memorable first impression. The uniformed men in the foreground are Balboa Guards who were stationed throughout the grounds "to be of service to visitors in all reasonable ways," according to a Keystone View Company card.

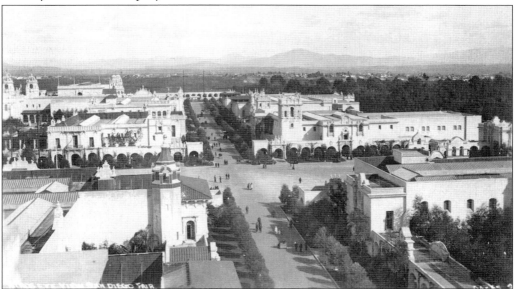

EL PRADO FROM ABOVE. One of the most popular vantage points for photographers of the exposition was the California tower, which tops out at 208 feet. This view looks east and shows the exhibit halls at the four corners of the Plaza de Panama. The buildings are (clockwise from upper left) Home Economy Building, Foreign Arts Building, Indian Arts Building, and Science and Education Building.

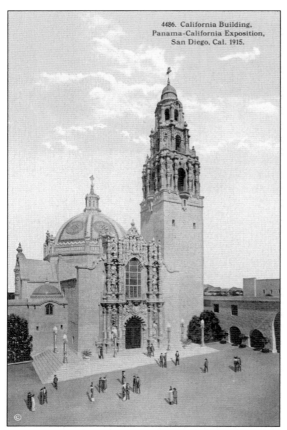

4486. California Building,
Panama-California Exposition,
San Diego, Cal. 1915.

CALIFORNIA BUILDING. No building in San Diego has been photographed more than the tile-domed California Building and its iconic bell tower. The highly ornamented structure has been called the best example of Spanish-baroque/Churrigueresque architecture in the world. Counter to popular myth, architect Bertram Goodhue did not copy a Spanish or Mexican building to create his masterpiece. Like every architect, Goodhue drew inspiration from great architecture of the world, especially 16th-century cathedrals and palaces, which he felt reflected San Diego's Spanish heritage and suited the climate. The California Building is also the best *sounding* building in San Diego, with its musical chimes ringing on the quarter hour. The original tower may have never had bells, but in 1946 a 30-chime carillon was installed. In 2007, prerecorded carillon music is piped through large loudspeakers.

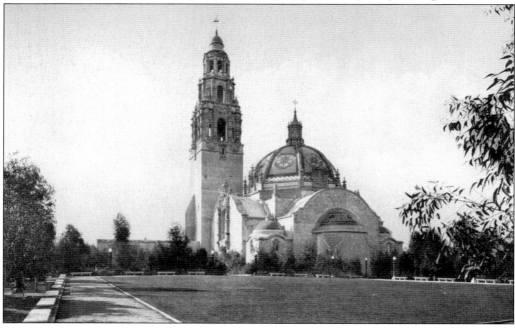

FRONTISPIECE. In architecture, a frontispiece is part of a facade highlighted by ornamentation. The frontispiece of the California Building, around the main entrance, is considered one of the finest in existence. The 73-foot-tall frontispiece is constructed of cast-concrete and incorporates bas-relief sculptures and busts of European explorers, religious figures, and royalty. The figure in the top center niche is Fr. Junipero Serra, founder of Mission San Diego de Alcalá in 1769.

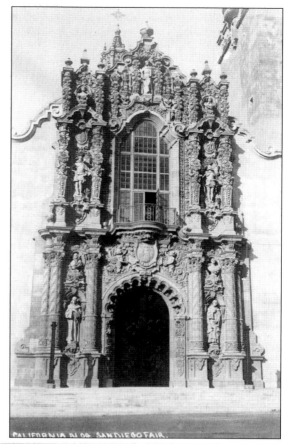

CALIFORNIA QUADRANGLE. The California Building connects to the south side of El Prado. The entire interconnected building is known as the California Quadrangle. At its center is the Plaza de California, seen in this postcard. The Fine Arts Building is located behind the tile-roofed arcade, and it displayed original paintings during the exposition, all of which were for sale. Today the building houses galleries for the Museum of Man.

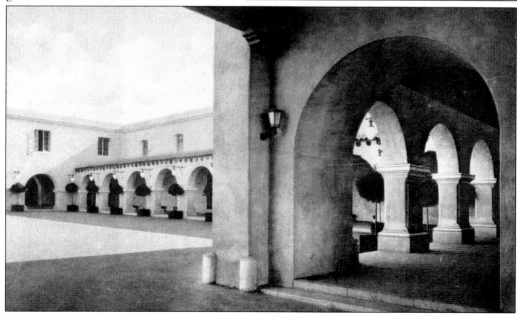

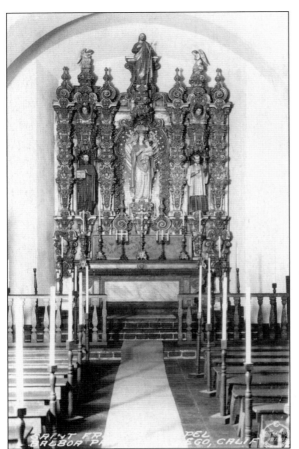

SAINT FRANCIS CHAPEL. A small Franciscan chapel is located at the southwest corner of the California Quadrangle. The interior includes an ornate gilded screen or reredos with a carved statue of Our Lady and Child, a wood balcony, terra cotta floor tile, and rough-hewn beams on the ceiling. The Saint Francis Chapel continues to be a popular site for weddings.

PRIMITIVE MAN. The California Building served as the host structure for the 1915 exposition, receiving dignitaries and special guests. The building also exhibited "memorials of a race that ran its course in America before the continent was seen by Europeans." In addition to the anthropology displays of native North Americans, the exhibits included these busts showing the evolution of man. The Museum of Man has operated their facility in the California Building since 1916.

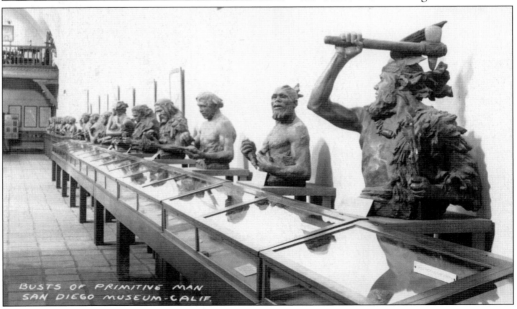

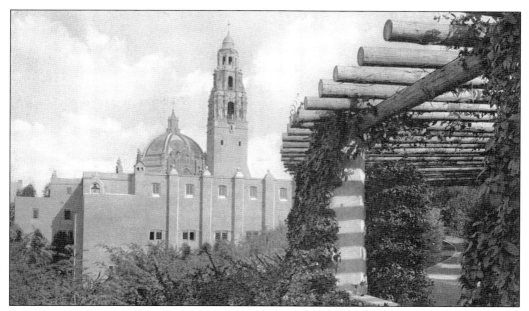

CALIFORNIA QUADRANGLE AND PERGOLA. This view shows the fortress-like south facade of the California Quadrangle, which was inspired by the design of Mission San Gabriel. Note the bell at the left of the façade that sits above the Saint Francis Chapel. The rustic pergola in the foreground no longer remains. In order to see this perspective of the California Quadrangle today, one must brave the archery range.

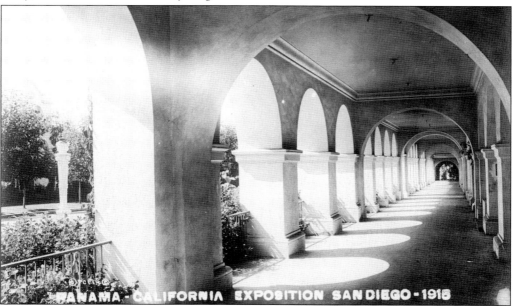

ARCADE. On hot days most pedestrians choose to walk under these shaded arcades rather than in the unprotected street. The arcade in this postcard was part of the Science and Education Building, which fell into disrepair and was demolished in 1964. In 2005, the arcade was reconstructed by the Committee of One Hundred and the City of San Diego in order to restore the 1915 look of continuous arcades along El Prado.

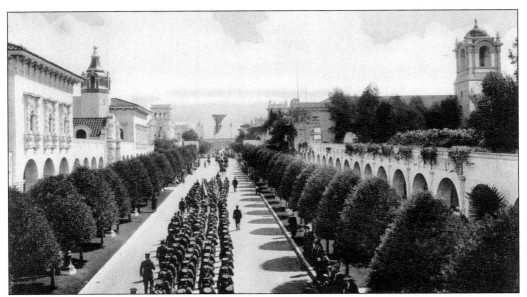

EL PRADO, LOOKING EAST. The primary east-west boulevard through the exposition grounds is known as El Prado. The Science and Education Building on the left was demolished and replaced by the San Diego Museum of Art's sculpture court and garden in the late 1960s. The Indian Arts Building (now the House of Charm, which houses the Mingei International Museum and the San Diego Art Institute gallery) is on the right.

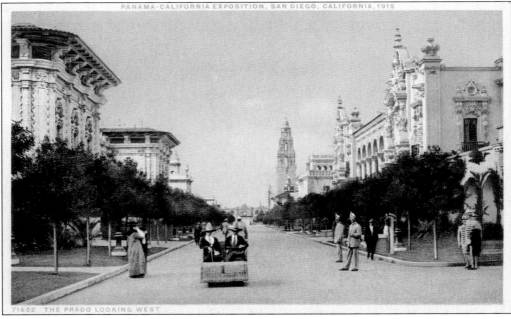

EL PRADO, LOOKING WEST. This view has changed very little since 1915. The structure to the left is the Commerce and Industries Building (now the Casa de Balboa) and the structure to the right is the Varied Industries Building (now the Casa del Prado). A group of Balboa Guards can be seen on the right. Their Spanish-inspired uniforms were light blue with yellow and black bars.

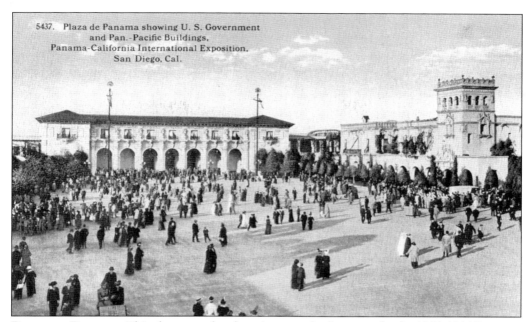

5437. Plaza de Panama showing U. S. Government and Pan.-Pacific Buildings, Panama-California International Exposition, San Diego, Cal.

PLAZA DE PANAMA. This plaza served as the primary gathering space for the 1915–1916 Panama-California Exposition. It functioned very much like a European town square and provided space for fairgoers to step back and appreciate the park's Spanish Colonial Revival architecture. The plaza was not paved at the time—it was topped with sandy, decomposed granite.

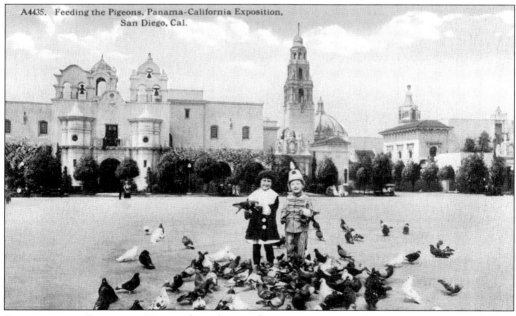

A4435. Feeding the Pigeons, Panama-California Exposition, San Diego, Cal.

FEEDING THE PIGEONS. Pigeons have been a fixture—many would say a menace—in Balboa Park since 1915. Feeding the pigeons in the Plaza de Panama was a popular fair activity. The boy in this photograph is dressed as a Balboa Guard. The Indian Arts Building (House of Charm) is on the left.

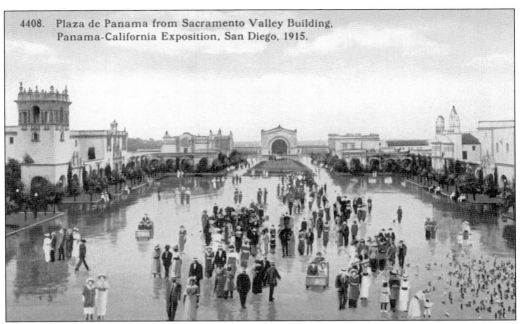

4408. Plaza de Panama from Sacramento Valley Building, Panama-California Exposition, San Diego, 1915.

PLAZA DE PANAMA, LOOKING SOUTH. This photograph was taken from the second floor of the Sacramento Valley Building. The Spreckels Organ Pavilion can be seen in the distance at the end of the Esplanade. This is a unique image because it shows the exposition grounds after a rare, heavy rain.

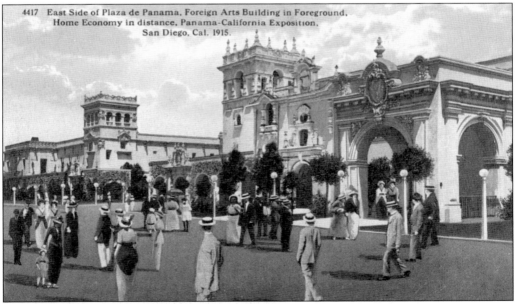

4417 East Side of Plaza de Panama, Foreign Arts Building in Foreground, Home Economy in distance, Panama-California Exposition, San Diego, Cal. 1915.

SISTER TOWERS. This view depicts the ornate, 60–foot–tall towers of the Foreign Arts Building (now the House of Hospitality) and the Home Economy Building. The symmetry of these two distinctive towers was lost when the Home Economy Building was demolished in 1963. Since many of these postcards were printed prior to the start of the exposition, it is not uncommon to see painted–in people like these.

PLAZA DE PANAMA, LOOKING SOUTHWEST. This view shows the adjacency of the Foreign Arts Building (House of Hospitality) to the San Joaquin Valley Building (right). The San Joaquin Valley Building was long and narrow because it sat on the edge of a canyon. Due to its unstable site, the building was demolished prior to 1935. In 1991, the Japanese Friendship Garden was built on this site.

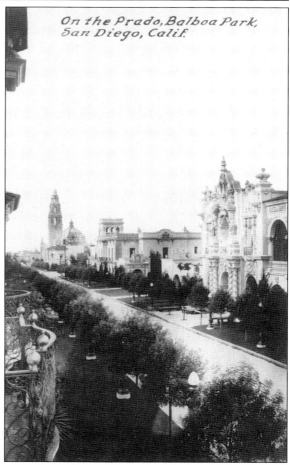

On the Prado, Balboa Park, San Diego, Calif.

EL PRADO BALCONY. This view looks northwest down El Prado from the second floor of the Commerce and Industries Building (renamed the Canadian Building in 1916 and now the Casa de Balboa). Note the glimmering ball finials on top of the wrought-iron railing at the left. They were originally painted with a bronze powder pigment that simulated gold leaf.

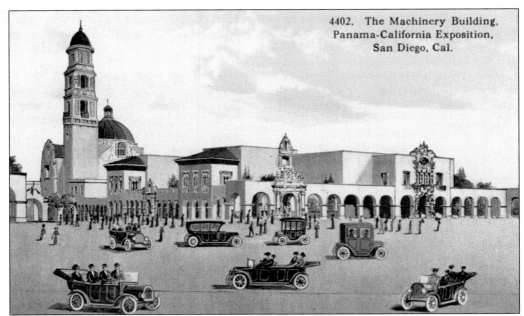

4402. The Machinery Building,
Panama-California Exposition,
San Diego, Cal.

MACHINERY BUILDING. The upper image shows the early name and design for what eventually became the Science and Education Building, seen in the bottom photograph. The building displayed exhibits by the Smithsonian Institution, Theosophical Society, and the Metropolitan Life Insurance Company whose exhibit, according to the 1915 *Guide Book*, demonstrated "how, by modern science and education of employees, the best interests of the community are served." Second floor offices were for marine colonel Joseph H. Pendleton who advocated the establishment of a permanent marine training base in San Diego. In 1942, the early California Pico family's Rancho Santa Margarita y los Flores north of San Diego was turned into the largest Marine Corps base in the country—named Camp Pendleton. Note that the odd, box-shaped automobiles shown in the upper image were Baker Electric cars.

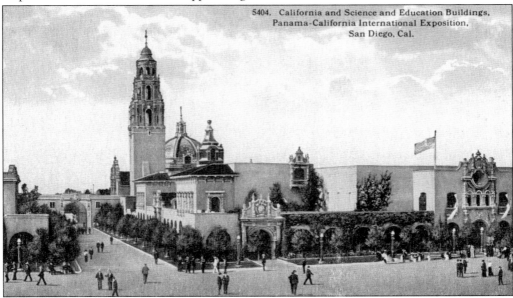

5404. California and Science and Education Buildings,
Panama-California International Exposition,
San Diego, Cal.

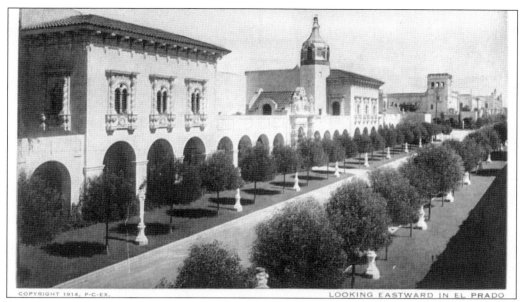

LOOKING EASTWARD IN EL PRADO

SCIENCE AND EDUCATION BUILDING, SOUTH FACADE. This was one of the first buildings that visitors saw as they entered the exposition grounds from the west. The Science and Education Building was demolished in 1964. The original architectural plans for this building are on file in the central library, so there are hopes that it can one day be reconstructed. Note the carefully groomed rows of black acacia trees along El Prado.

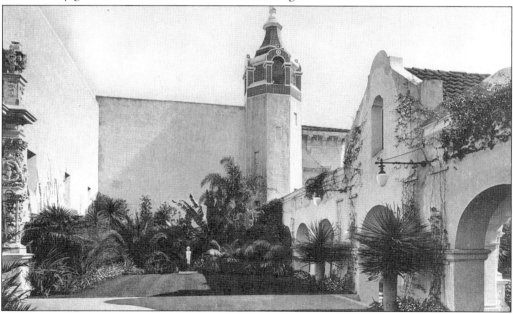

SCIENCE AND EDUCATION, PATIO. The Science and Education Building was unique for its tile-clad Moorish stair tower and its use of clay mission roof tile. The upper portion of the tower was clad in black and yellow ceramic tile. This postcard features a lush patio that led to the main south entrance. This building was renamed the Palace of Science and Photography for the 1935 exposition.

33

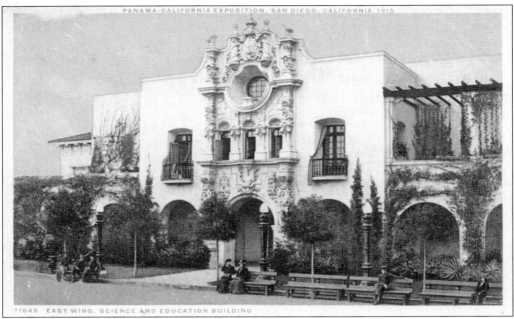

71649 EAST WING, SCIENCE AND EDUCATION BUILDING

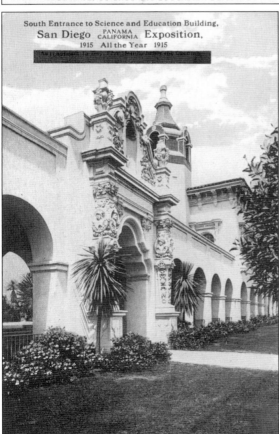

South Entrance to Science and Education Building,
San Diego PANAMA CALIFORNIA **Exposition,**
1915 All the Year 1915

SCIENCE AND EDUCATION BUILDING, EAST FACADE. This facade of the Science and Education Building had a very different appearance than the facade on El Prado. Interesting features in this view include the round window above the main entrance and the redwood pergola on the rooftop at the right. Note the flowering bougainvillea and curtains draped over the balcony rails that were used to add splashes of color.

SCIENCE AND EDUCATION BUILDING, SOUTH ENTRANCE. This ornate portal was located at the center of the arcade facing El Prado. The text under the blacked-out bar reads: "As it appears To-Day, Five Months before the Opening." These cards were printed prior to the start of the exposition to generate public interest. The leftover postcards were sold during the fair with this not-so-subtle masking of the obsolete text.

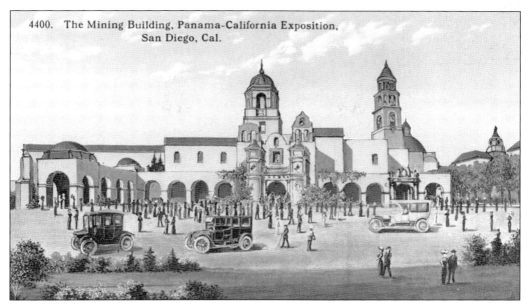

4400. The Mining Building, Panama-California Exposition, San Diego, Cal.

MINING BUILDING. The name of this structure changed to the Indian Arts Building prior to the start of the 1915 exposition. It was renamed the Russia and Brazil Building in 1916. Finally, the building was renamed the House of Charm in 1935. This temporary structure was reconstructed in 1996 and became the home of the Mingei International Museum. The distinctive design, with twin bell gables, recalls the Sanctuario de Guadalajara in Mexico.

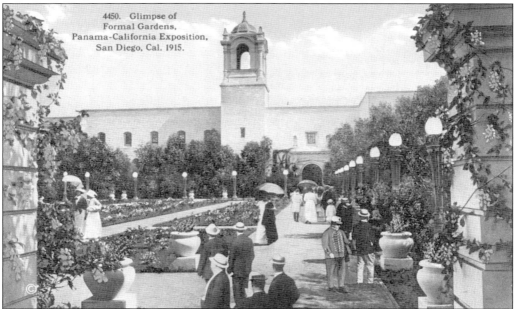

4450. Glimpse of Formal Gardens, Panama-California Exposition, San Diego, Cal. 1915.

INDIAN ARTS BUILDING AND GARDENS OF MONTEZUMA. One of the better-known gardens in Balboa Park is the Alcazar Gardens behind the House of Charm. Many do not realize that the original name of this garden in 1915 was the Gardens of Montezuma. The 1935 name change and makeover included adding colorful tile fountains and benches. This view also provides the best vantage point to see the elegant Puebla tower.

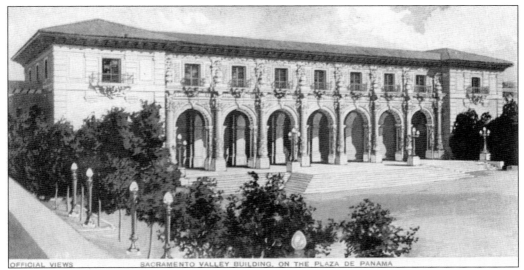

SACRAMENTO VALLEY BUILDING, ON THE PLAZA DE PANAMA

SACRAMENTO VALLEY BUILDING. This classically proportioned building was centered on the north end of the Plaza de Panama. Despite its beauty and artistic detailing, this building—like most of the 1915 exposition structures—was never intended to last. And it didn't. The Sacramento Valley Building, renamed the United States Building in 1916, was demolished in 1924 and replaced two years later by the Fine Arts Gallery, now known as the San Diego Museum of Art.

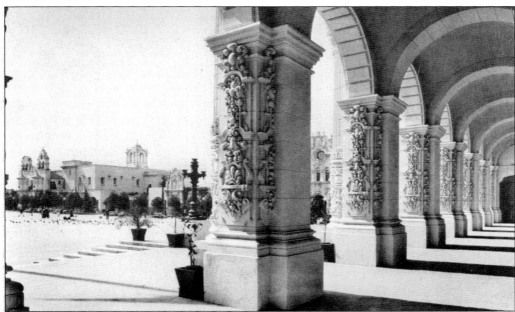

SACRAMENTO VALLEY BUILDING, ARCADE. This close-up view displays the intricate Spanish-Revival ornamentation that characterizes the architecture of the 1915 exposition. Sculptor H. L. Schmohl molded the original pieces in clay. Then "staff plaster" castings were made and nailed to wood framing. Staff plaster is simply plaster of paris reinforced with hemp fiber. The material was inexpensive and lightweight, but it was never used for building exteriors intended to be permanent.

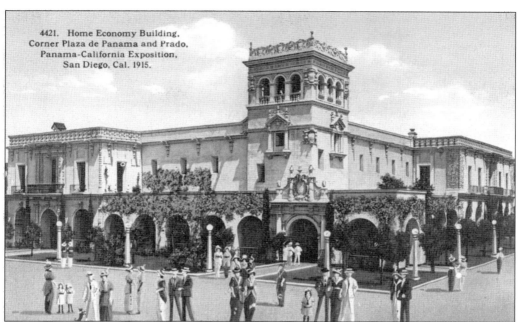

4421. Home Economy Building, Corner Plaza de Panama and Prado, Panama-California Exposition, San Diego, Cal. 1915.

HOME ECONOMY BUILDING.

According to the 1915 *Guide Book*, this structure was "devoted principally to showing to women what has been done to better conditions in the home." A model kitchen "demonstrated that the farm wife of today has just as much right to relief from drudgery in the home as her husband has in the meadows and barns." The Home Economy Building was renamed the Pan-Pacific Building in 1916 and was later renamed the Café of the World in 1935. The design of the corner tower was closely modeled after the Palace of Monterey in Salamanca, Spain, built in 1539. The bottom view shows San Diego Red bougainvillea that was trained to cover the arcade. The Home Economy Building was demolished in 1963 to make way for the elegantly modern, but harshly incompatible, Timken Museum of Art.

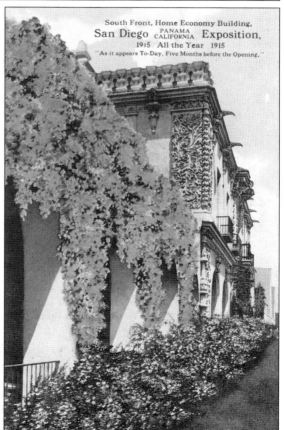

South Front, Home Economy Building, San Diego PANAMA CALIFORNIA Exposition, 1915 All the Year 1915 "As it appears To-Day, Five Months before the Opening."

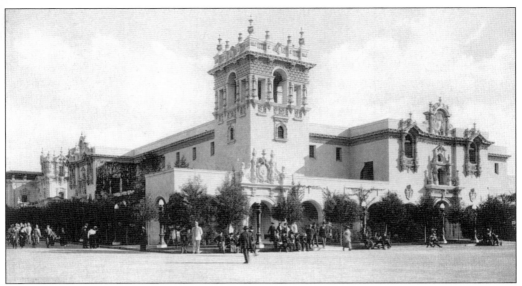

FOREIGN ARTS BUILDING. This structure was inspired by the Hospital of Santa Cruz in Toledo, Spain. The coats of arms on the exterior walls and tower represent countries of the Pan-American Union. The building housed lacquer work, bronze, and silk from Japan and China. In addition, artisans and craftsmen from the Orient, Russia, and Italy displayed their embroidery, wood-carving, and glass-cutting skills. The building was rechristened the House of Hospitality in 1935. This once-temporary structure was made permanent when it was reconstructed in 1997. The award-winning reconstruction included replacing the staff plaster ornamentation with permanent concrete castings and meticulously restoring and reinstalling over 6,000 original features including windows, light fixtures, and stenciled beams. The 2007 House of Hospitality has a ballroom, meeting rooms, a restaurant, offices, and the Balboa Park Visitors Center. The building is at the right side of the bottom image.

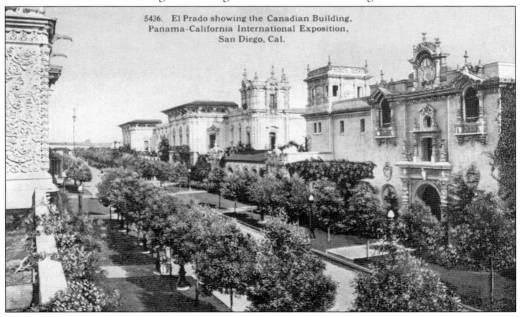

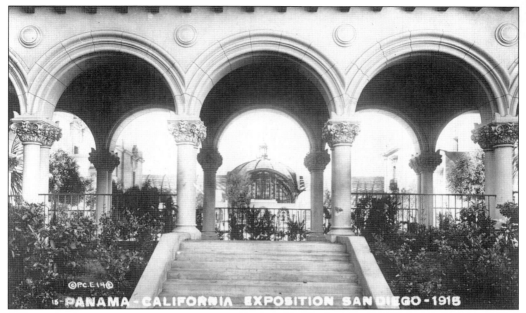

ORNATE ARCADE. This view looks north toward the Botanical Building through the arcade that connects the Foreign Arts Building to the Commerce and Industries Building. This strong visual axis is one of many planned throughout the grounds. This is one of the few 1915 arcades with a clay tile roof. The intricately detailed column capitals are unique to this arcade.

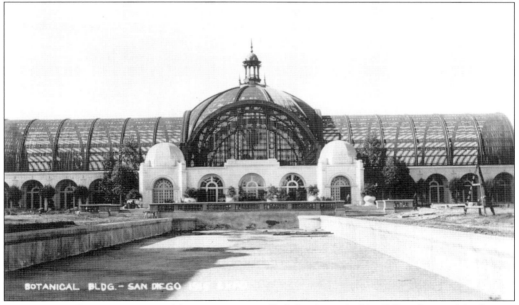

BOTANICAL BUILDING. Exposition promoters called the Botanical Building "one of the largest lath-covered structures in existence." It measured 250 feet long, 75 feet wide, and 60 feet tall. The picturesque building was clad with 70,000 feet of redwood lath supported by a steel frame. Note that this photograph was taken during construction from the bottom of the dry lagoon.

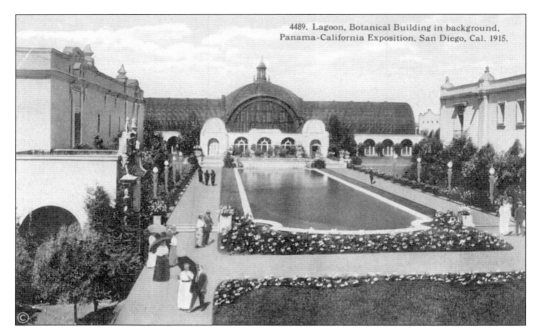

4489. Lagoon, Botanical Building in background, Panama-California Exposition, San Diego, Cal. 1915.

BOTANICAL BUILDING. The vaulted form of the Botanical Building resembled a transparent train station and was fronted by a stucco arcade with a pair of segmented domes above the entrances. The structure was originally built with a steel and glass conservatory wing centered at the rear of the main building. Exposition visitors could only see the conservatory from the inside. The conservatory was demolished in 1959 along with the front arcade wings. The "Lath House," as it was often called, housed tropical bamboo, ferns, banana trees, carnivorous specimens, and many other curious and beautiful plants. In addition, linnets, thrushes, and canaries in birdcages were contained in the airy, sun–dappled interior.

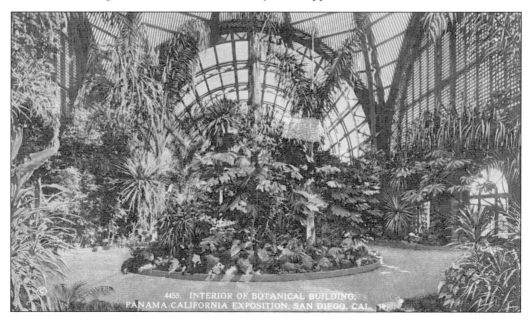

4455. INTERIOR OF BOTANICAL BUILDING, PANAMA-CALIFORNIA EXPOSITION, SAN DIEGO, CAL. 1915.

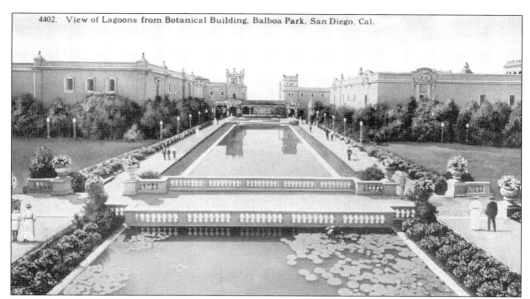

LAGUNA DE LAS FLORES. The reflecting pool in front of the Botanical Building was named Laguna de las Flores (pool of the flowers). A Keystone View card notes, "In spots like this, turmoil of San Diego's industry is forgotten, the present disappears from mind, and the romantic past of Spanish California returns." The 50,000-gallon north pool and 250,000-gallon south pool were filled with lilies and other aquatic plants. In later years, koi fish and turtles were introduced.

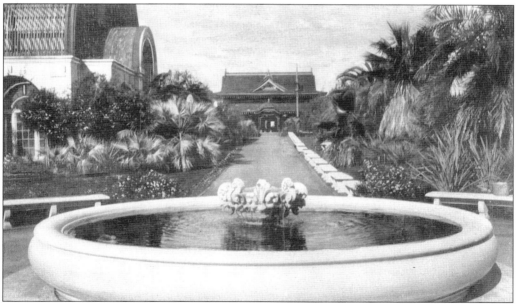

FOUNTAIN AND JAPANESE TEA HOUSE. East of the Botanical Building was the tiny Japanese Tea Garden and Tea House. In the foreground of this view is a circular fountain with four gargoyle faces on the fountainhead. There is a twin to this fountain at the west end of the Botanical Building. In 2006, the Friends of Balboa Park organization funded the replication of both fountainheads, which had been missing for many years.

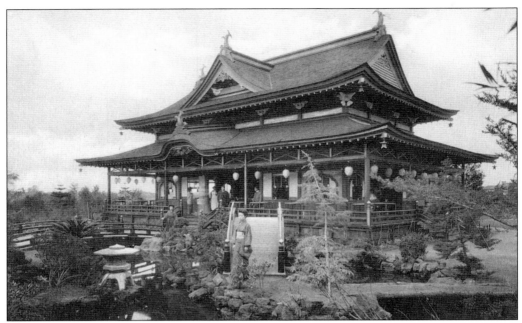

JAPANESE TEA HOUSE AND GARDEN. This Buddhist temple–like pavilion was surrounded by gardens and a flowing stream to create a traditional Japanese setting. According to the 1915 *Guide Book*, "He who is able to cross the [moon] bridge without slipping on its shapely-curved surface is assured of long life." All the parts for the Tea House were made in Japan and shipped to San Diego where Japanese carpenters assembled the house using traditional building techniques like tenons and pegs. Inside the building, women in silk kimonos served tea, rice cakes, and green ice cream on bamboo mats. In 1955, at the urging of the Zoological Society, the Tea House and Garden were demolished to make way for a children's zoo. In 1991, Japanese culture returned to Balboa Park when the 11.5-acre Japanese Friendship Garden was built north of the Spreckels Organ Pavilion.

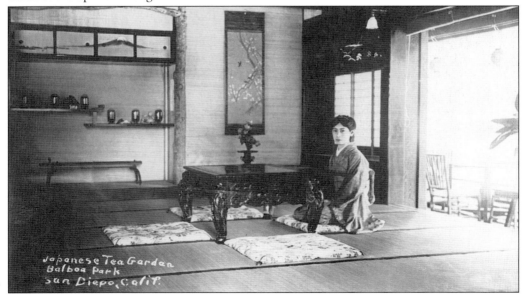

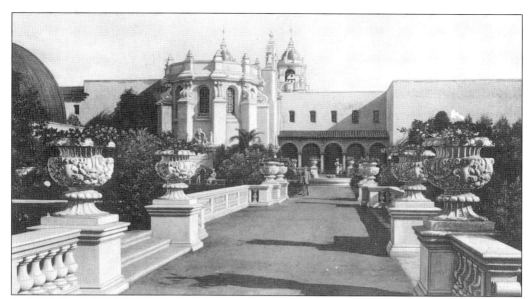

BOTANICAL GARDENS AND VARIED INDUSTRIES BUILDING. This view is looking east across a footbridge that separates the two parts of Laguna de las Flores. Large, ornate planter urns mark the intersections of stairs and walkways. The rounded "chapel apse" to the left side of the Varied Industries Building had large brackets and arched windows. This architectural feature was not replicated when the building was reconstructed as the Casa del Prado in 1971.

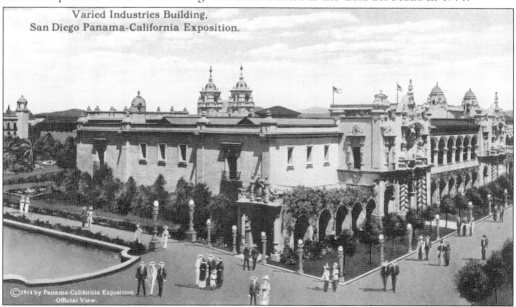

VARIED INDUSTRIES BUILDING. The varied Industries and Food Products Building included an array of exhibits that showed "the processes rather than products." According to the *Guide Book*, the 1915 exhibits included "a complete bread and cake making plant . . . a cracker company . . . a sea–food company . . . and a winery . . . gathering the grapes and pressing them for the best vintages." The building was renamed the Foreign and Domestic Building in 1916 and the Palace of Food and Beverages in 1935.

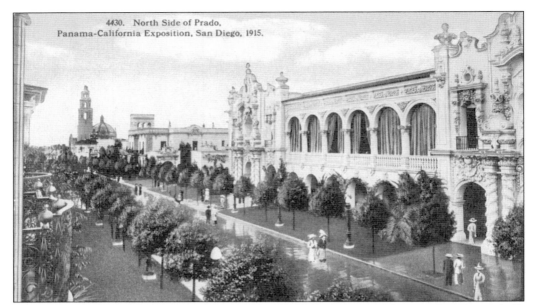

VARIED INDUSTRIES BUILDING, SOUTH FACADE. This was the largest of the exhibition halls and featured a unique second-floor arcade balcony that faced El Prado. The facade ornamentation included fruit and vegetable embellishments because the building was originally intended to display agricultural exhibits. Note the large draperies that hung in the upper arcade, which, according to the *Guide Book*, added "much to the effectiveness of the building" in 1915.

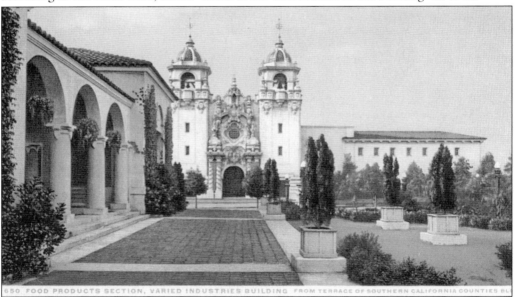

VARIED INDUSTRIES BUILDING, EAST FACADE. The chapel-like east facade of the Varied Industries Building (Casa del Prado) included two flanking bell towers with tiled domes and wrought-iron finials. This view looks across the terrace of the Southern California Counties Building. The San Diego Public Library was located in this building from 1952 to 1954, while a new, downtown library was being completed. The San Diego Junior Theatre now stages productions here.

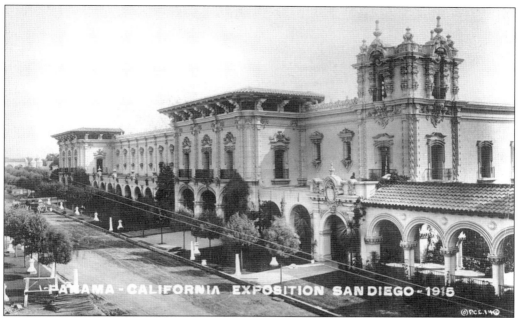

COMMERCE AND INDUSTRIES BUILDING, NORTH FACADE. This building is now known as the Casa de Balboa. Other names included the Canadian Building in 1916, the Palace of Better Housing in 1935, and the Electric Building. This was the location of the Museum of Natural History prior to construction of their permanent home in 1933. In 1965, the building became the first home of the San Diego Aerospace Museum before the building was destroyed by fire in 1978.

COMMERCE AND INDUSTRIES BUILDING. Perhaps the most talked— and snickered—about architectural features in Balboa Park are the nude women below the eaves of this building. Rumors abound as to the origin of these generously endowed women, who were likely just a playful reference to classical architecture. The frieze panels between the women were originally painted deep blue, red, green, and gold. Unfortunately, the colors were omitted from the 1982 reconstruction.

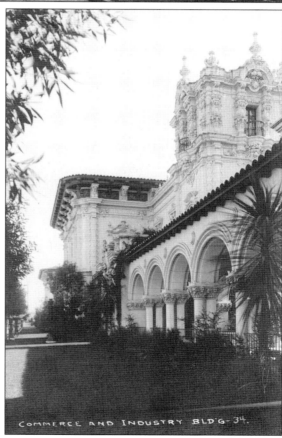

COMMERCE AND INDUSTRY BLD'G-34.

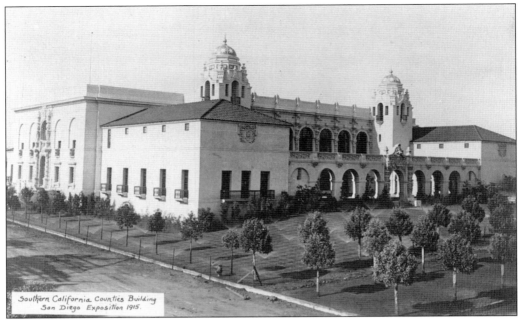

Southern California Counties Building
San Diego Exposition 1915.

SOUTHERN CALIFORNIA COUNTIES BUILDING. This imposing structure was sponsored by the seven counties of Imperial, Los Angeles, Orange, Riverside, San Bernardino, San Diego, and Ventura. The symmetrical design was marked by two towers that framed a large forecourt. The two-level arcade was inspired by the Convent of San Augustin in Queretaro, Mexico. The bottom image shows the south patio, which served as a quiet retreat. In the 1920s, the Southern California Counties Building became a 3,000-seat Civic Auditorium. On November 25, 1925, the building was destroyed by a spectacular fire. According to the *San Diego Union*, "The fire started about 7 o'clock as the auditorium was being made ready for the annual Firemen's Ball. . . . The flames shot hundreds of feet into the air and were seen in all parts of the city." In 1933, the Natural History Museum was built on this site.

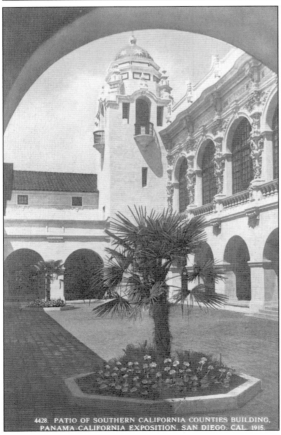

4428. PATIO OF SOUTHERN CALIFORNIA COUNTIES BUILDING, PANAMA-CALIFORNIA EXPOSITION. SAN DIEGO. CAL. 1915.

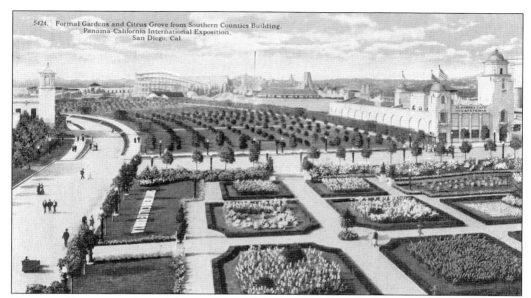

FORMAL GARDENS. One of the purposes of the 1915 exposition was to promote San Diego's ideal climate for growing virtually anything. A full 24 pages of the exposition *Guide Book* were dedicated to listing the plantings done years in advance throughout the fairgrounds. The Formal Gardens and Citrus Grove were located on five acres north of the Southern California Counties Building. Note the Isthmus fun zone roller coaster at the upper left.

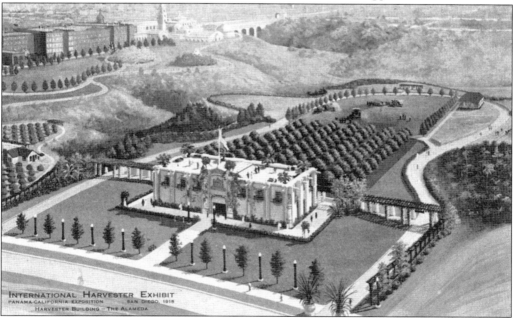

INTERNATIONAL HARVESTER EXHIBIT. Continuing with the agricultural theme, the International Harvester Company constructed a building, Model Orchard, and Demonstration Field to promote how their farm equipment helped to rapidly change deserts "into fruitful gardens." This postcard illustration shows the location of the International Harvester exhibit in relation to the California tower and Cabrillo Bridge. The San Diego Zoo now occupies this land.

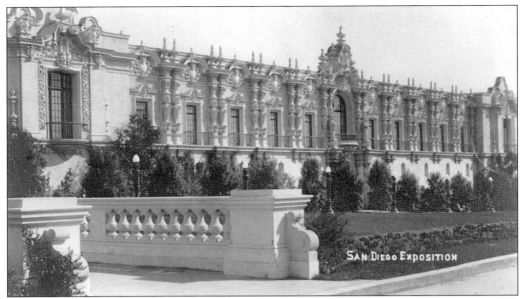

SAN JOAQUIN VALLEY BUILDING. This building, which architect Bertram Goodhue described as having a "long florid facade," was built south of the Foreign Arts Building (House of Hospitality). In his memoir, Goodhue wrote that this is an "almost over-ornamented example of the civic work in Mexico during the Baroque or Churrigueresque period." The design of this building was unique for the exposition because it had no exterior arcade. The San Joaquin Valley Building was used to display the goods of central California. In addition to exhibits about mining and fruit growing, the beautiful interior (bottom) featured unique decorations in fine grains and grasses that covered panels on the walls and ceiling. The San Joaquin Valley Building fell into disrepair and was demolished prior to the 1935 exposition. The Japanese Friendship Garden now occupies a portion of this site.

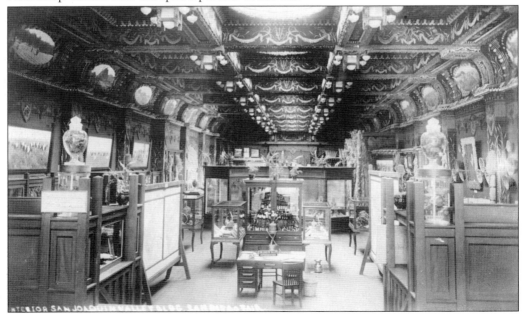

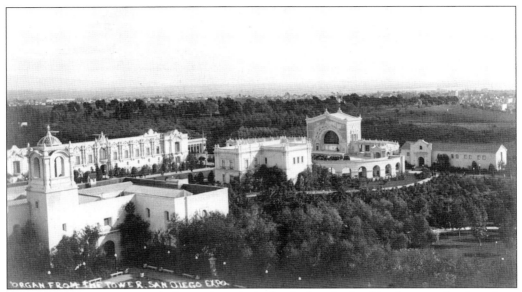

ESPLANADE. Running south from El Prado is the Esplanade. In this photograph taken from the California tower, one can see (from left to right) the Puebla tower and Indian Arts Building (House of Charm), the San Joaquin Valley Building, the Kern and Tulare Counties Building, the Spreckels Organ Pavilion, and the Alameda and Santa Clara Counties Building. Only the Spreckels Organ Pavilion and reconstructed House of Charm remain.

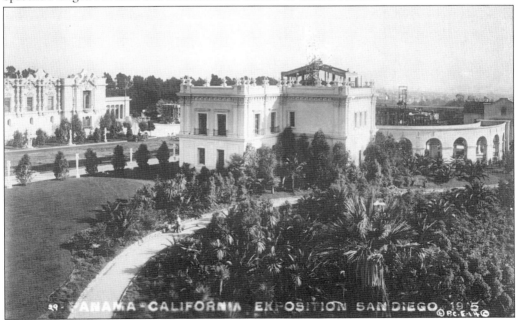

KERN AND TULARE COUNTIES BUILDING. This view provides a better look at the Kern and Tulare Counties Building. Inside the structure, according to a Keystone View card, "If the visitor be interested in a particular exhibit of alfalfa which he sees, he can be shown exactly where it was grown." Note the photographer's attempt to mask the construction scaffolding at the Organ Pavilion in the distance.

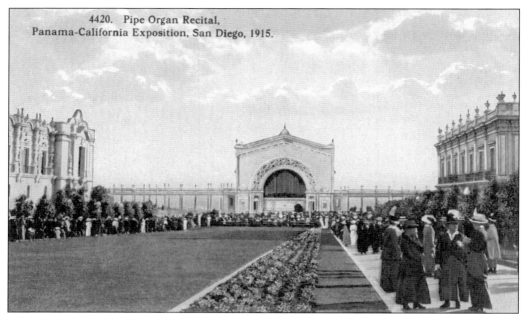

4420. Pipe Organ Recital,
Panama-California Exposition, San Diego, 1915.

SPRECKELS ORGAN PAVILION. The south end of the Esplanade terminated at the Spreckels Organ Pavilion, one of the most unique structures in Balboa Park. Millionaire sugar magnate, railroad tycoon, developer, and organ enthusiast John D. Spreckels and his brother Adolph B. Spreckels donated this building to the exposition. It soon became known as "the largest outdoor pipe organ in the world." Spreckels brought in his own architect, Harrison Albright, to design the pavilion in a style more Greek than Spanish. In 1915, the 3,400-pipe organ cost $33,500, and the building cost another $66,500. Only 15 of the large pipes visible in the arched opening were functional, the rest were for appearances only. In the bowels of the organ house, real pipes ranging in size from 32 feet to a few inches do the real work. In 2007, there are 4,518 pipes distributed among five divisions.

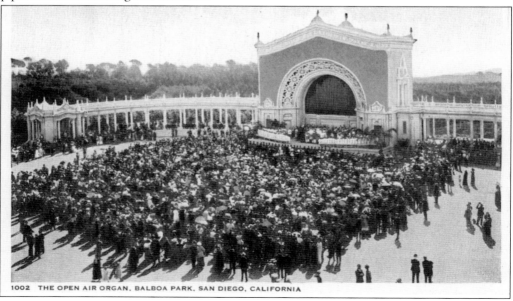

1002 THE OPEN AIR ORGAN, BALBOA PARK, SAN DIEGO, CALIFORNIA

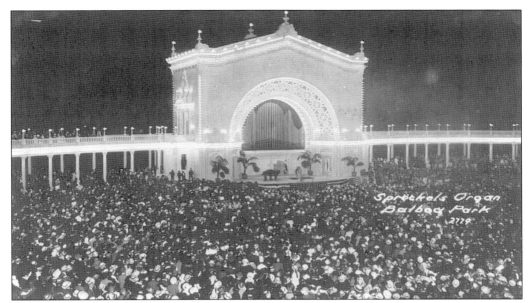

SPRECKELS ORGAN PAVILION. The curved colonnades were designed to embrace thousands of visitors who still attend organ performances, choirs, and special events. The Spreckels Organ Pavilion was one of the few permanent structures built in 1915. At night, the pavilion's 1,734 exterior lights include 112 rooftop finials with flame-shaped glass globes. The exterior lighting and electrical system were completely restored and upgraded in 2006.

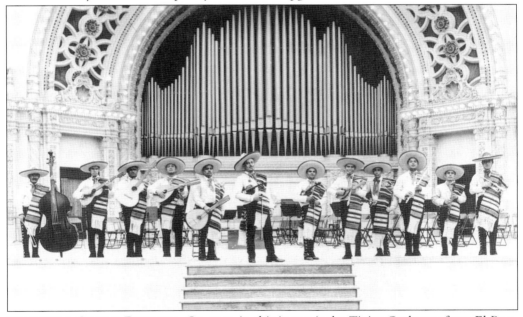

SPRECKELS ORGAN PAVILION. On stage in this image is the Tipica Orchestra from El Paso, Texas. The pavilion was oriented to face north in order to protect the delicate instrument from the heat of the sun. In addition to pipes, the organ includes chimes, drums, cymbals, and a concert harp—all connected to a keyboard console. When the Spreckels Organ Pavilion is not open for performances, a large, metal roll-down door closes off the arched proscenium.

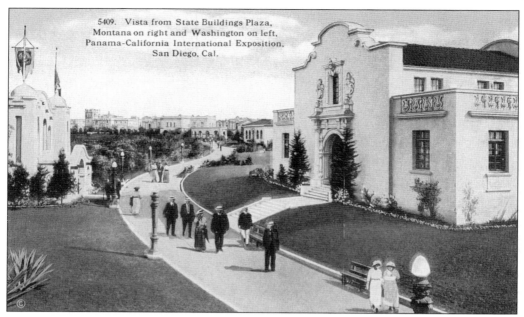

STATE BUILDINGS PLAZA. On a lower plateau south of the Esplanade were located five state buildings: Kansas, Utah, Washington, Montana, and New Mexico. In this view looking north, the Montana State Building can be seen on the right and the Washington State Building on the left. Since San Francisco's Panama-Pacific International Exposition was the "official" exposition of 1915, many states elected to build their state houses up north and bypass San Diego.

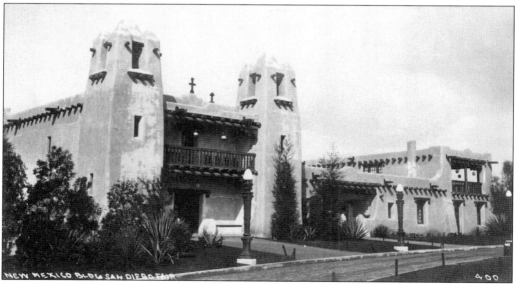

NEW MEXICO BUILDING. This pueblo-style structure was based on the design of the Church of San Estevan Acoma in New Mexico. Note the lack of arches and ornamentation and the use of traditional exposed log vigas penetrating the faux-adobe walls. This is one of only two surviving state buildings in what is now the Palisades area. Renamed the Palace of Education in 1935, the building is currently the Balboa Park Club.

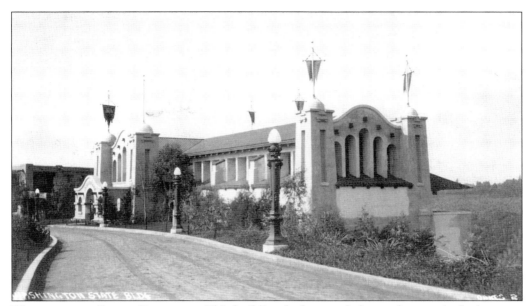

WASHINGTON STATE BUILDING. This building had a rear balcony that overlooked a steep canyon, visible on the right. The series of slender vertical arches below the curved parapets created oddly interesting facades for this building. Inside the Evergreen State's exhibits emphasized "forestry, fruit, and fisheries." The Washington State Building was demolished prior to the 1935–1936 California Pacific International Exposition.

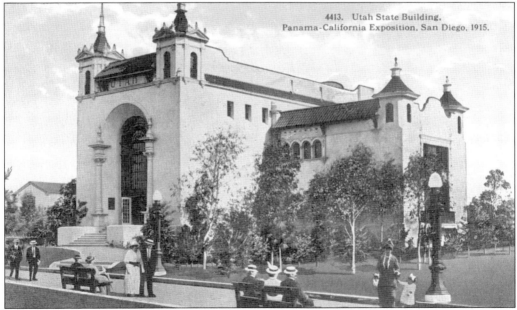

UTAH STATE BUILDING. The design of the Utah State Building appeared to try to meld Spanish Revival with Mormon architecture. The steeple-topped corner towers are a clear reference to the 1867 Mormon Temple in Salt Lake City. The mission tile roof is obviously Spanish Revival, and the series of arched windows is a characteristic shared by both styles. This building was also demolished prior to the 1935–1936 exposition.

53

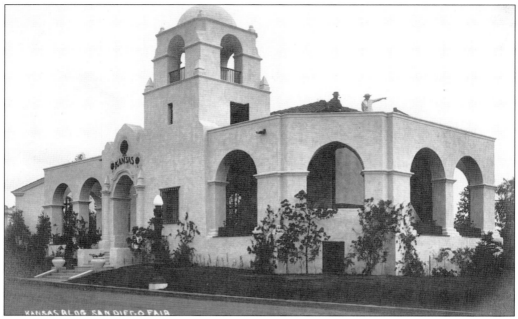

KANSAS STATE BUILDING. This small structure is reminiscent of the mission San Luis Ray in Oceanside. The men pictured here are standing on a rooftop verandah. In 1916, this building changed its name and use to the Theosophical Headquarters. then in 1935, it was used as the Press Building—with a full-time bartender. It is now called The Hall of Nations/House of Italy and the domed tower has been removed.

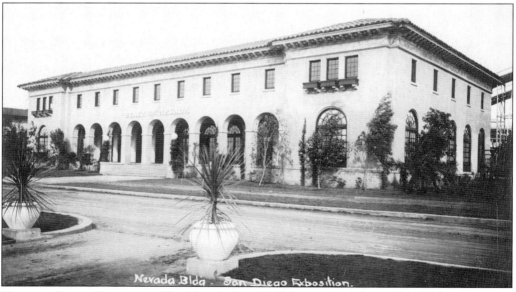

NEVADA STATE BUILDING. The Nevada State Building was not located with the other state buildings. The original plan was to locate the structure between the Utah and Montana buildings, but due to construction delays, it was instead built north of El Prado, adjacent to the Model Farm. When the Nevada State Building was threatened with demolition in 1923, it was moved by the San Diego Zoological Society and turned into the zoo's Children's Center.

Three

ANIMALS GET A HOME

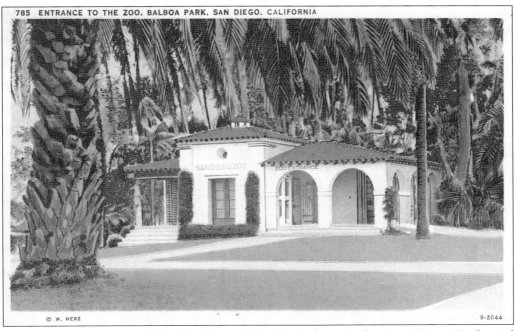

785 ENTRANCE TO THE ZOO, BALBOA PARK, SAN DIEGO, CALIFORNIA

© H. HERZ 9-2044

SAN DIEGO ZOO. In 1916, Dr. Harry Wegeforth formed the San Diego Zoological Society. Strong public interest and generous donations followed, and by 1922 the San Diego Zoo had a permanent home in Balboa Park. This tiny structure once served as the main entrance to the zoo. In 2007, the 123-acre San Diego Zoo is home to over 4,000 animals—many rare or endangered.

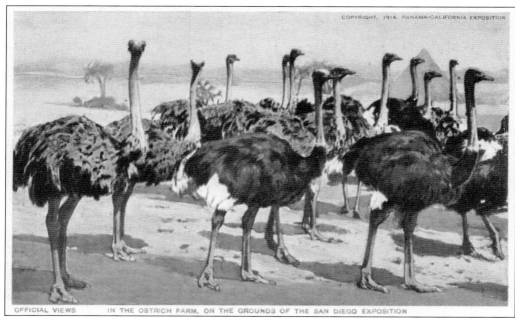

OFFICIAL VIEWS IN THE OSTRICH FARM, ON THE GROUNDS OF THE SAN DIEGO EXPOSITION

OSTRICH FARM. A reporter at the 1916 exposition stated that "most of the animals are friendly—in their strong iron cages—and their trainer has them all well in hand, eliminating, it is said, all possible danger." The zoo began with a handful of these animals that had been caged, quarantined, and virtually abandoned after the 1915–1916 Panama-California Exposition. Cawston's Ostrich Farm, seen in this postcard, was located in the Isthmus fun zone.

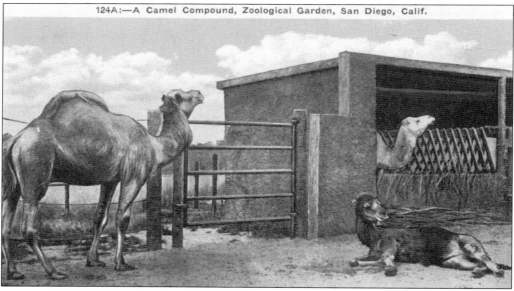

124A:—A Camel Compound, Zoological Garden, San Diego, Calif.

CAMEL COMPOUND. This image shows one of the rudimentary enclosures, possibly temporary, during the early years of the zoo. It is likely that this image shows the "three fine camels" described in the June 19, 1923, *San Diego Union*, which were from the "herd assembled for use in some scenes of 'The Ten Commandments,' " which had recently concluded filming in San Francisco. Cecil B. DeMille produced two versions of the biblical tale, in 1923 and again in 1956.

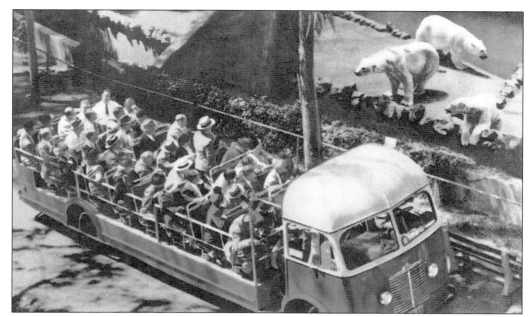

TOUR BUSES. This postcard, postmarked 1955, shows one of the zoo's open-topped busses in front of the polar bear enclosure. The message on this card from "Jim" to a friend in West Virginia reads, "Was in this zoo. Don't know why they didn't keep me."

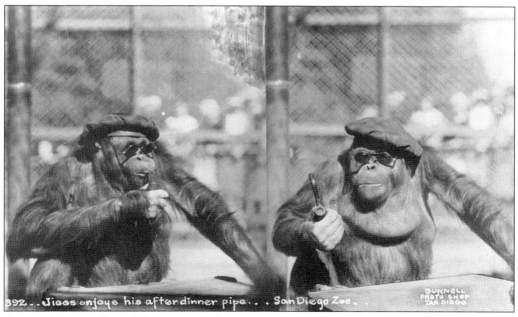

392 . . Jiggs enjoys his after dinner pipe . . . San Diego Zoo .

BUNNELL
PHOTO SHOP
SAN DIEGO

AFTER-DINNER PIPE. This postcard shows two views of Jiggs, the pipe-smoking orangutan. Jiggs and his "wife," Maggie, were popular attractions at the zoo in the 1930s. While smoking is still allowed in designated areas of the zoo, pipe-smoking primates are a thing of the past. In later years, Ken Allen, one of the zoo's orangutans, became famous for his creative escapes. He had a fan club, T-shirts, bumper stickers, and even a song in his honor.

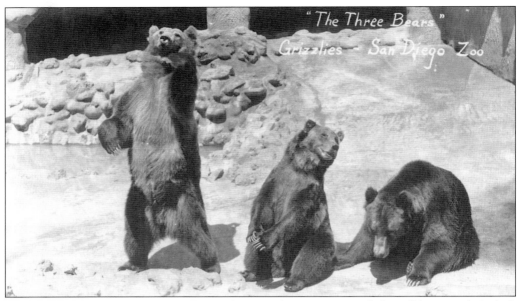

GRIZZLY BEARS. North America brown bears are known as "grizzly bears" because their dark fur is tipped with white, giving them a grizzled appearance. The largest grizzly ever captured in California, weighing in at 2,200 pounds, was taken in Valley Center in 1866. The rural community is less than 40 miles north of the zoo and was appropriately named Bear Valley after the incident but renamed Valley Center in 1887.

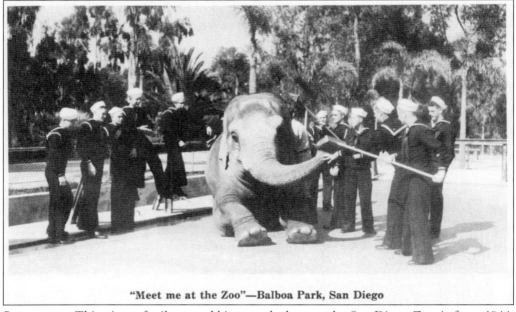

SHIPSHAPE. This view of sailors scrubbing an elephant at the San Diego Zoo is from 1944. Elephants were popular attractions in the Midget Circus during the 1935–1936 California Pacific International Exposition. At one time, it was possible for children and adults to take elephant and camel rides at the zoo. Today the typical elephant at the San Diego Zoo eats 125 pounds of food every day.

GOAT MOUND. The *Official Guide* of the 1935 exposition notes that the zoo housed "more than 2,500 specimens" and "Mrs. Belle Benchley, the curator of the Zoo, is the only woman zoo keeper in the world." The guide also states, "Visitors find the open grottos for bears and cats and the artificial mounds for sheep and goats to be the most remarkable of all the animal enclosures."

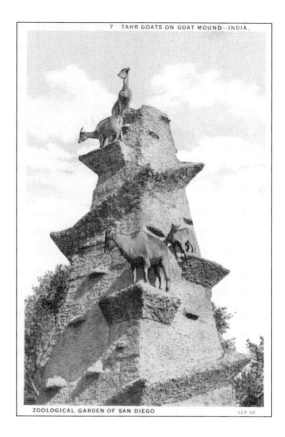

7 TAHR GOATS ON GOAT MOUND—INDIA.

ZOOLOGICAL GARDEN OF SAN DIEGO 527-30

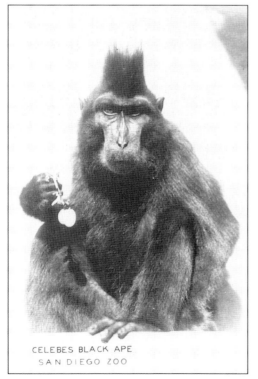

CELEBES BLACK APE
SAN DIEGO ZOO

NOT AN APE. It turns out that this "Celebes Black Ape" with the Mohawk-looking hairdo is actually a macaque, which is a type of monkey. Macaques are one of the species of monkey that have cheek pouches, which are used to hold food so they can chew it later. Recently the San Diego Zoo opened the Monkey Trails exhibit, a naturalistic environment that replaced the old monkey cages that were built in 1922.

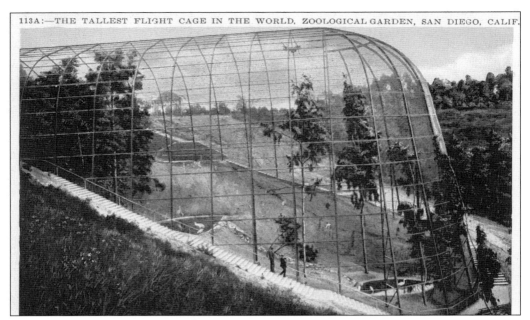

FLIGHT CAGE. Funded by La Jolla naturalist Ellen Browning Scripps, this hillside cage was touted as "The Tallest Flight Cage in the World." A January 1, 1929, *San Diego Union* story noted, "There are now more than 220 birds comprising 20 species inhabiting this aviary. The trees furnish shelter and nesting places, and in addition, caves are built into the terraced walls. Running water and pools add to the natural setting for the wading birds, such as egret and flamingo."

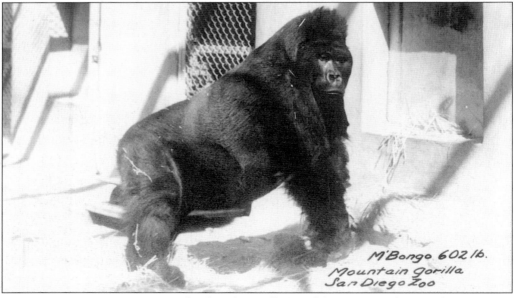

M'Bongo 602 lb.
Mountain gorilla
San Diego Zoo

MOUNTAIN GORILLA. Former schoolteacher Belle Benchley was zoo director from 1927 to 1953. In 1930, she convinced well-known naturalists Osa and Martin Johnson to bring their famous mountain gorillas, Mbongo and Ngagi to the San Diego Zoo, where they became a popular draw. The zoo currently attracts 3.5 million visitors per year. Bronze portraits of these popular gorillas still greet zoo visitors near the entrance.

Four

THE NAVY MOVES IN

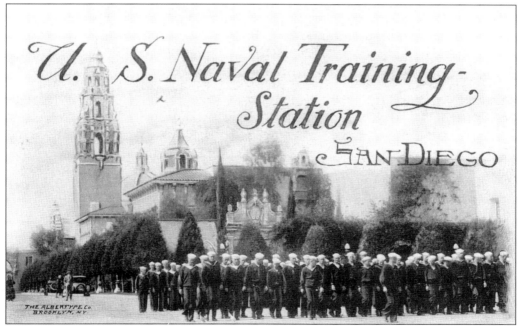

U.S. NAVAL TRAINING STATION, 1917. On April 6, 1917, the United States declared war on Germany and entered World War I. The U.S. Navy quickly transformed Balboa Park's exposition grounds into San Diego's first Naval Training Station. The navy's rental of the city-owned buildings and grounds was free of charge. On May 13, 1917, the *San Diego Union* wrote, "The changes which have been made in the various buildings will not impair either the utility or beauty of any of the structures inside or out."

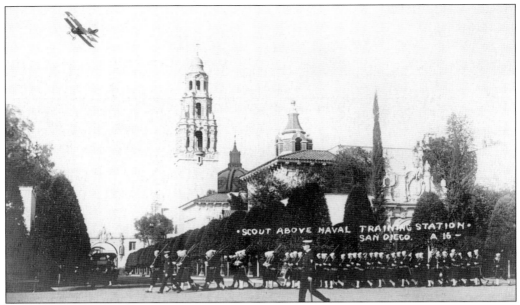

SCOUT PLANE. The navy biplane shown in this postcard was likely based at Rockwell Field on North Island. According to the *San Diego Sun* in 1917, "Only the best men available are being taken in the flying corps, as upon these men will devolve the duty of guarding the fleets from attack by hostile aircraft and submarines." The San Joaquin Valley Building was used for the naval aviation school.

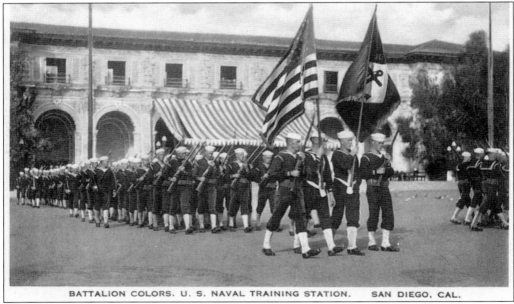

BATTALION COLORS. By 1918, the naval training station had 6,000 bluejackets who were, according to the *San Diego Union*, "Being instructed in every phase of naval life" in Balboa Park. After 90 days, the sailors were "ready to take [their] place in the finest body of seafighters in the world." The sailors' average age was 19, and they were paid $35 a month. The building in the background is the Sacramento Valley Building, demolished in 1923.

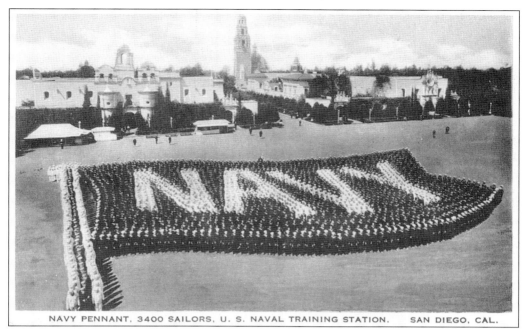

NAVY PENNANT, 3400 SAILORS, U. S. NAVAL TRAINING STATION.　SAN DIEGO, CAL.

NAVY PENNANT. This image was taken in 1918 from the roof of the Foreign Arts Building (House of Hospitality) looking west across the Plaza de Panama. The hand-written message on this card reads, "How do you like this flag, it takes quite a few men to make a flag like this." According to the caption, it takes 3,400.

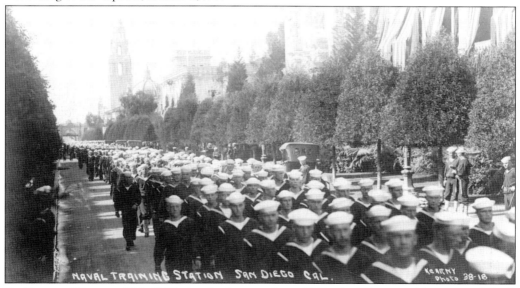

EL PRADO MARCH. This 1918 view looks west down El Prado. The exposition grounds look much as they did during 1915–1916. On May 20, 1917, the *San Diego Union* reported, "San Diegans who feared that the soldiers and sailors would destroy the foliage can set their minds at rest. The men now there are taking as much interest in the upkeep of the foliage and buildings as if they belonged to them. They say they are delighted to have the privilege of camping in such ideal surroundings."

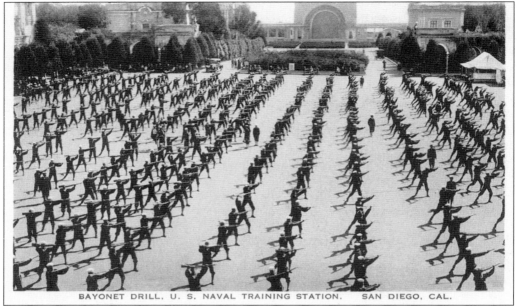

BAYONET DRILL, U. S. NAVAL TRAINING STATION. SAN DIEGO, CAL.

PLAZA ACTIVITIES. The Plaza de Panama was the scene of a wide variety of navy activities, from bayonet drills to Saturday night dances. The June 24, 1917, *San Diego Union* reported, "At a bayonet drill Thursday morning several of the apprentice seamen did not go through the exercise with the vigor demanded by the instructor, a husky gunner's mate with a foghorn voice, that boomed clear across the Plaza de Panama. 'Right thrust, parry, left thrust, lunge,' shouted the instructor. 'Now listen, shipmate, you haven't got a pitchfork in your hands. Handle that gun as if you were face to face with a German.'" In the bottom image, more than 5,000 officers, enlisted men, and their friends enjoyed an evening dance. The Home Economy Building (left) and the Foreign Arts Building (center) can be seen in the background.

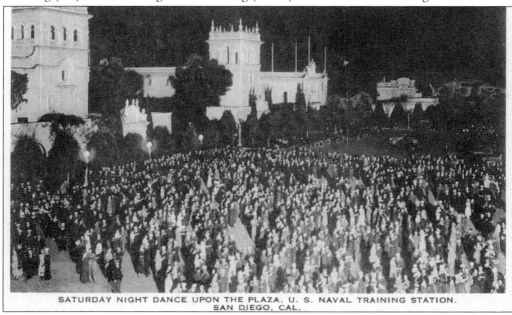

SATURDAY NIGHT DANCE UPON THE PLAZA, U. S. NAVAL TRAINING STATION.
SAN DIEGO, CAL.

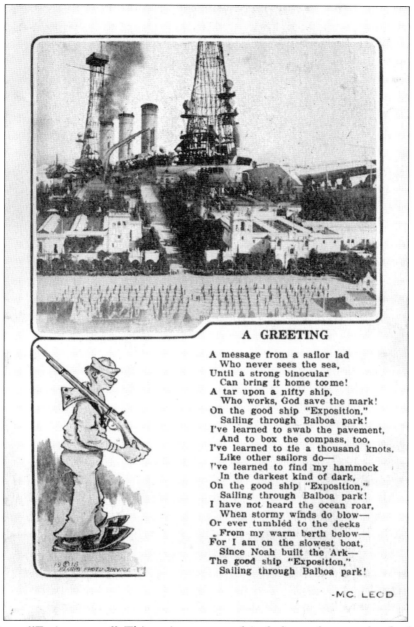

A GREETING

A message from a sailor lad
　　Who never sees the sea,
Until a strong binocular
　　Can bring it home to me!
A tar upon a nifty ship,
　　Who works, God save the mark!
On the good ship "Exposition,"
　　Sailing through Balboa park!
I've learned to swab the pavement,
　　And to box the compass, too,
I've learned to tie a thousand knots,
　　Like other sailors do—
I've learned to find my hammock
　　In the darkest kind of dark,
On the good ship "Exposition,"
　　Sailing through Balboa park!
I have not heard the ocean roar,
　　When stormy winds do blow—
Or ever tumbled to the decks
　　From my warm berth below—
For I am on the slowest boat,
　　Since Noah built the Ark—
The good ship "Exposition,"
　　Sailing through Balboa park!

—MC. LEOD

GOOD SHIP "EXPOSITION." This unique postcard includes a photograph of a battleship joined with an aerial view of the exposition grounds. While Balboa Park served its military mission well, it was not a permanent solution to the navy's needs. The July 8, 1918, *San Diego Union* stated, "But one thing . . . is lacking in the camp, and that is sufficient opportunity for aquatic instruction. There is . . . a canyon, which may be so dammed that if filled with water, it would make a lake . . . providing plenty of space for maneuvering of boats, races and water sports." Alas the canyon was never filled with water, but the U.S. Navy did get a permanent waterfront training facility in 1923 when the Naval Training Center, or NTC, was constructed on Point Loma.

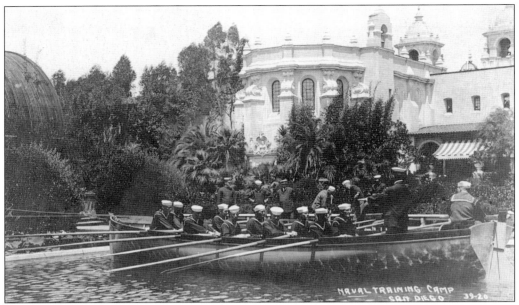

LAGOON TRAINING. The navy had to be creative in order to find water for training. In these two postcards, recruits learn to row and swim in the 4.5-foot-deep lagoon in front of the Botanical Building. The July 8, 1918, *San Diego Union* reported, "Jack gets instruction on two regulation navy 25-foot cutters in the swimming pool (top image). The pool is too small for maneuvering, but, nevertheless by the time his instruction is finished, he has learned the handling of oars and sails. . . Here, too, he gets his swimming lessons . . . (bottom image). Jack really learns to swim before he ever strikes the water—but whether he has learned to swim or not, the pool has greater attractions for him these summer days than any other form of amusement." Unlike the open ocean, in Balboa Park, weak swimmers could cheat by walking on the bottom.

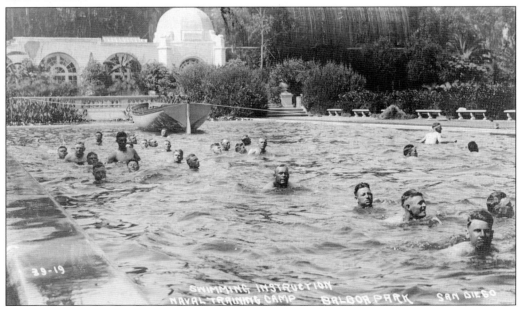

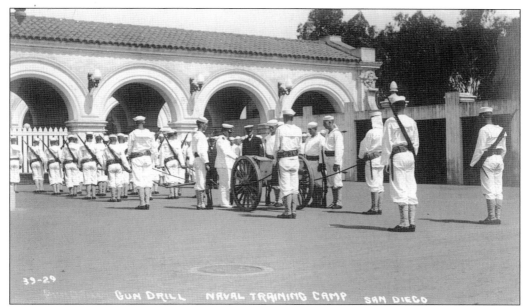

GUN DRILL. The gun drill shown is this postcard is taking place near the East Gate of the exposition. In July 1918, according to the *San Diego Union*, the navy was having second thoughts about leaving Balboa Park. "It is believed that the government will make the present camp a permanent station and will replace the Exposition buildings, many of which are deteriorating rapidly, with edifices specially adapted to [the navy's] needs." Thankfully that plan never transpired.

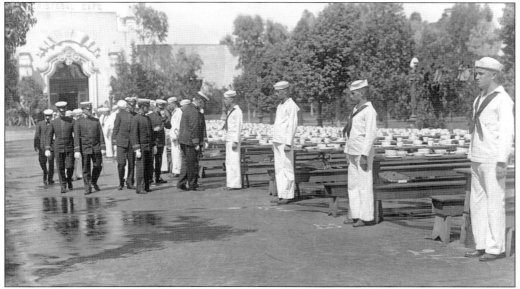

MESS INSPECTION. The Cristobal Café, built for the 1915 exposition, was recycled by the U.S. Navy. The January 1, 1918, *San Diego Union* reported, "The Cristobal café, the scene of many a brilliant banquet during the Exposition period, was converted into a galley, bakeship [sic] and mess hall within twenty days after the government took possession." Dining took place outdoors at the wood benches and tables seen in this postcard.

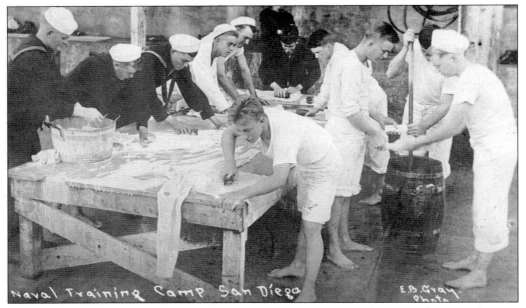

WASHING CLOTHES. The hand-written message on this postcard, postmarked October 12, 1918, says it best: "Mother, this is the way we have to scrub our clothes. Of course we are not dressed up like this, we are generally stripped of them. —Frank."

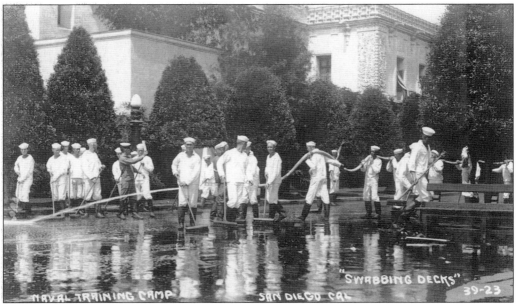

SWABBING DECKS. Since real ships were in short supply in Balboa Park, the navy made do with what it had available. In this case, the Plaza de Panama stood in for a ship's wood deck. In March 1918, the *San Diego Union* reported about "rumors that dissatisfaction exists among 4,000 bluejackets attached to [the] station" but concluded that they were false and "attributed to pro-German sources." The structure in the background is the Home Economy Building.

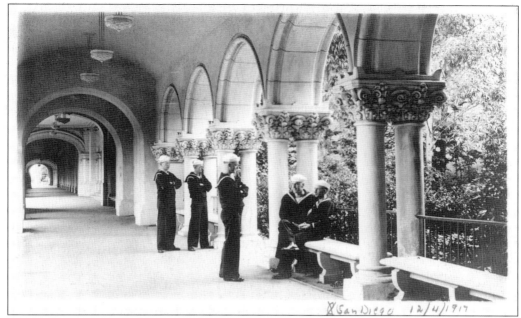

RELAXING IN AN ARCADE. The arcades of Balboa Park, designed for the 1915 exposition, were, according to architect Bertram Goodhue, "Repeated in various places throughout the length of the Prado and tend greatly to harmonize and unify the buildings of varying architectural epochs to which they are adjacent." This attractive arcade spans between the House of Hospitality and the Casa de Balboa and was faithfully reconstructed in 1997.

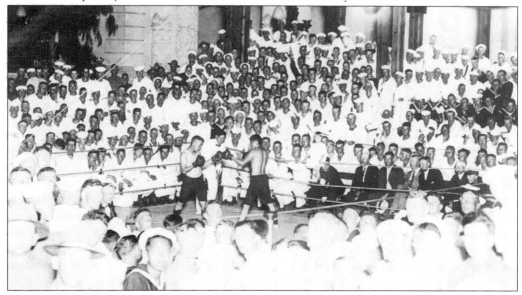

BOXING NIGHT. In 1918, the *San Diego Union* reported, "The opening round of a 5-week boxing tourney will be held Monday evening, August 12, on the Plaza de Panama and will consist of six bouts." It is not clear whether this postcard shows that particular event, but since almost everyone except the boxers are looking at the camera, it is clear that this photograph was staged.

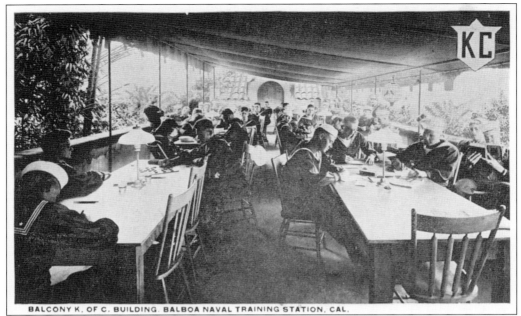

BALCONY K. OF C. BUILDING, BALBOA NAVAL TRAINING STATION, CAL.

ROOFTOP READING ROOM. The "KC" shield on this card stands for Knights of Columbus, a fraternal benefit society for Catholic men over 18. This reading room was on the arcade rooftop of the Science and Education Building, where a makeshift fabric canopy provides shade. Also at the training station was a branch of the public library maintained by the YMCA in the Indian Arts Building (House of Charm).

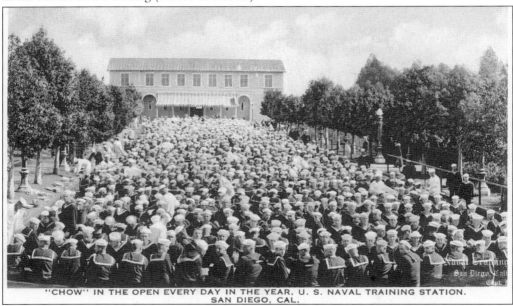

"CHOW" IN THE OPEN EVERY DAY IN THE YEAR, U. S. NAVAL TRAINING STATION. SAN DIEGO, CAL.

"CHOW" TIME. The July 8, 1918, *San Diego Union* describes a typical sailor's dining experience, "Jack is usually a person of well-developed appetite, and he not only wants good food, but he wants lots of it. The outstanding feature is . . . the great open-air dining room, which is in the street." A large, fabric awning was eventually erected to provide diners with protection from the sun.

Five

BETWEEN THE EXPOS

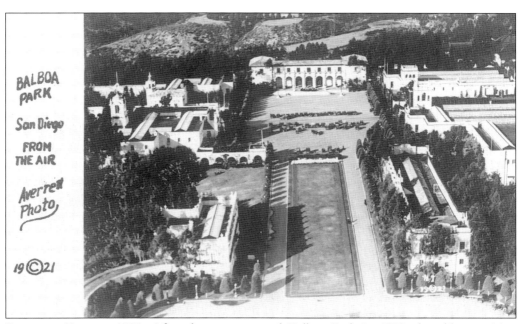

PARKING PLAZA, 1921. After the navy vacated Balboa Park in 1919, the old exposition grounds were reopened to the public. Several museums occupied the vacated buildings of the 1915–1916 Panama-California Exposition. This aerial view looks north across the Esplanade to the Plaza de Panama. The narrow building on the right is the San Joaquin Valley Building. Note that automobiles have already begun to take over the plaza.

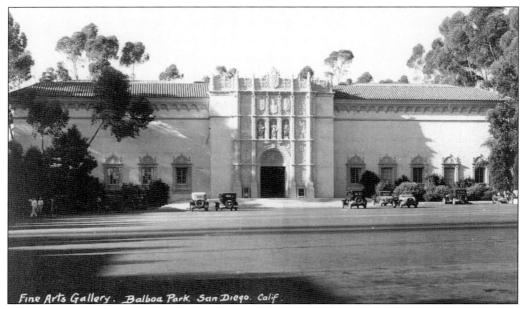

Fine Arts Gallery. Balboa Park. San Diego. Calif.

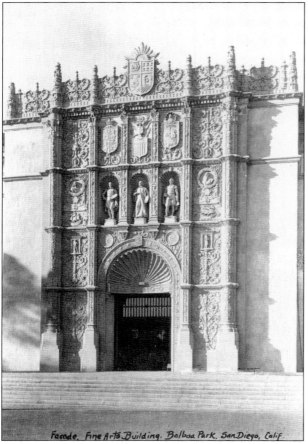

Facade, Fine Arts Building. Balboa Park, San Diego, Calif.

FINE ARTS GALLERY. On the site that was once occupied by the Sacramento Valley Building, the Fine Arts Gallery was constructed in 1926. In 1935, the building was called the Palace of Fine Arts and is now the San Diego Museum of Art. The structure was designed in the Spanish Colonial Revival style by famed San Diego architect William Templeton Johnson. Johnson also designed the Junipero Serra Museum on Presidio Hill in 1929 and the Museum of Natural History in 1933.

FINE ARTS GALLERY, FRONTISPIECE. The dramatic frontispiece above and around the main entrance of the Fine Arts Gallery was sculpted by Chris Mueller and his son Chris Jr. The junior Mueller would go on to sculpt for Disneyland's Haunted Mansion and Jungle Boat ride. Chris Mueller Jr. also worked in Hollywood and helped sculpt the giant squid from *20,000 Leagues Under the Sea* (1954) and the title character from *The Creature from the Black Lagoon* (1954).

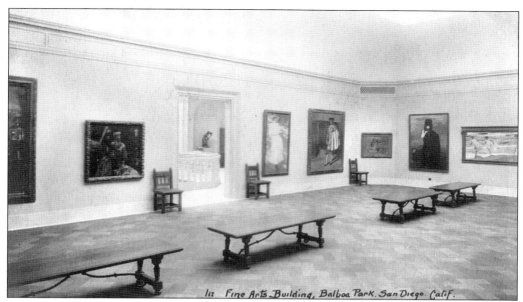

In Fine Arts Building, Balboa Park, San Diego, Calif.

FINE ARTS GALLERY, INTERIOR. This postcard shows the newly completed interior of the Fine Arts Gallery (Museum of Art). The second-floor galleries were once filled with abundant natural light from large skylights above. A grand staircase in the entry foyer features ornamentation sculpted by the Muellers. The ceiling of the foyer is coffered wood with rich stenciling, reflecting designs inspired by Spanish interiors.

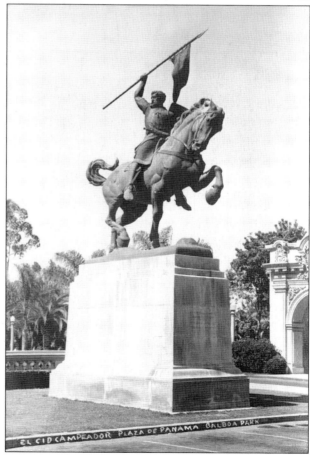

EL CID CAMPEADOR PLAZA DE PANAMA BALBOA PARK

EL CID CAMPEADOR. This statue, on the south end of the Plaza de Panama, was unveiled on July 5, 1930. Sculpted by Anna Hyatt Huntington, it was a gift to San Diego from the Hispanic Society of New York. El Cid (*c.*1040–1099) was a great Castilian nobleman, political leader, and warrior. In equestrian statuary, many believe that when one horse foreleg is raised, it means that the rider died of wounds after a battle, but El Cid died of natural causes.

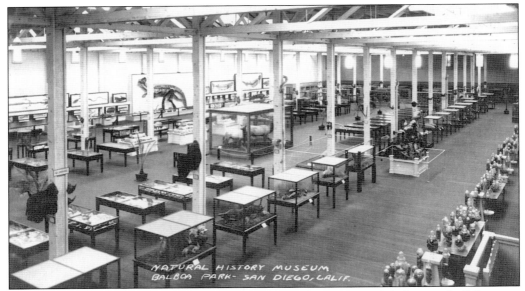

TEMPORARY NATURAL HISTORY MUSEUM. The Commerce and Industries Building was the home of the Museum of Natural History prior to completion of their own building in 1933. This is a rare view of one of the typical unadorned exposition interiors. Note the simple, white-washed wood posts and trusses and the wood floor. Large skylights and high windows provide natural day lighting. This building was destroyed by fire in 1978 and rebuilt as the Casa de Balboa.

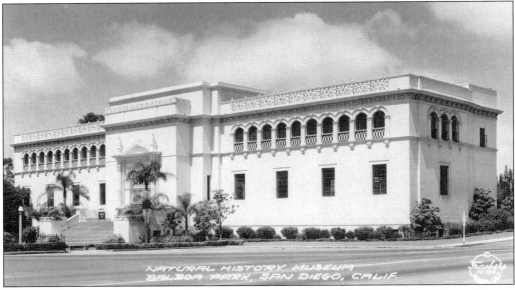

NATURAL HISTORY MUSEUM. This building was also designed by William Templeton Johnson between the expositions, in 1933. The Southern California Counties Building was originally located on this site, but it burned down in 1925. The museum is topped by a balustrade parapet consisting of stylized sea creatures. The main entrance, located on the second floor, is reached by ascending a flight of steps from the south. Two Egyptian cats sit atop columns that frame the entry.

74

Six

ANOTHER EXPO TO THE RESCUE

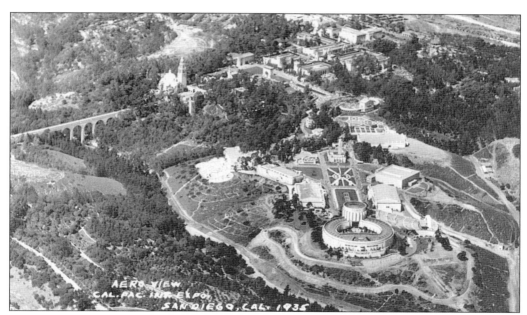

AERO VIEW, 1935. Still feeling the effects from the Great Depression in 1933, San Diego's civic boosters believed that another exposition in Balboa Park would help the economy and promote the city as a business and tourist destination. The 1935 California Pacific International Exposition, also known as "America's Exposition," was born. This aerial view shows the new buildings at the lower right, paid for in part by the first WPA funds allocated to an American city.

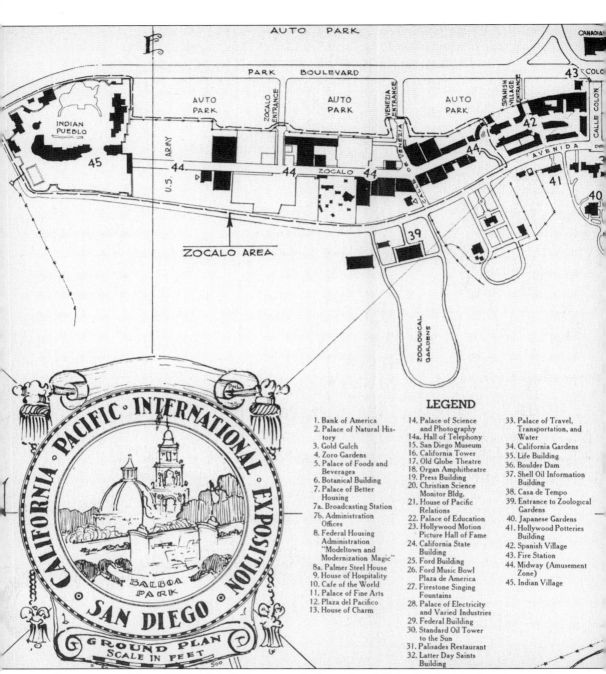

LEGEND

1. Bank of America
2. Palace of Natural History
3. Gold Gulch
4. Zoro Gardens
5. Palace of Foods and Beverages
6. Botanical Building
7. Palace of Better Housing
7a. Broadcasting Station
7b. Administration Offices
8. Federal Housing Administration "Modeltown and Modernization Magic"
8a. Palmer Steel House
9. House of Hospitality
10. Cafe of the World
11. Palace of Fine Arts
12. Plaza del Pacifico
13. House of Charm

14. Palace of Science and Photography
14a. Hall of Telephony
15. San Diego Museum
16. California Tower
17. Old Globe Theatre
18. Organ Amphitheatre
19. Press Building
20. Christian Science Monitor Bldg.
21. House of Pacific Relations
22. Palace of Education
23. Hollywood Motion Picture Hall of Fame
24. California State Building
25. Ford Building
26. Ford Music Bowl Plaza de America
27. Firestone Singing Fountains
28. Palace of Electricity and Varied Industries
29. Federal Building
30. Standard Oil Tower to the Sun
31. Palisades Restaurant
32. Latter Day Saints Building

33. Palace of Travel, Transportation, and Water
34. California Gardens
35. Life Building
36. Boulder Dam
37. Shell Oil Information Building
38. Casa de Tempo
39. Entrance to Zoological Gardens
40. Japanese Gardens
41. Hollywood Potteries Building
42. Spanish Village
43. Fire Station
44. Midway (Amusement Zone)
45. Indian Village

EXPOSITION MAP, 1935. This foldout map is from the *Official Guide*. North points to the left. Most of the buildings along El Prado, renamed Avenida de Palacios, remain from the 1915–1916 exposition. The most significant additions along El Prado include the Palace of Natural History (No. 2), Palace of Fine Arts (No. 11), and the Old Globe Theatre (No. 17). Where the state buildings were once located, on the right side of the map, several large, new buildings were constructed, including the Hollywood Motion Picture Hall of Fame (No. 23), California State Building (No. 24), Ford Building and Bowl (No. 25 and No. 26), Palace of

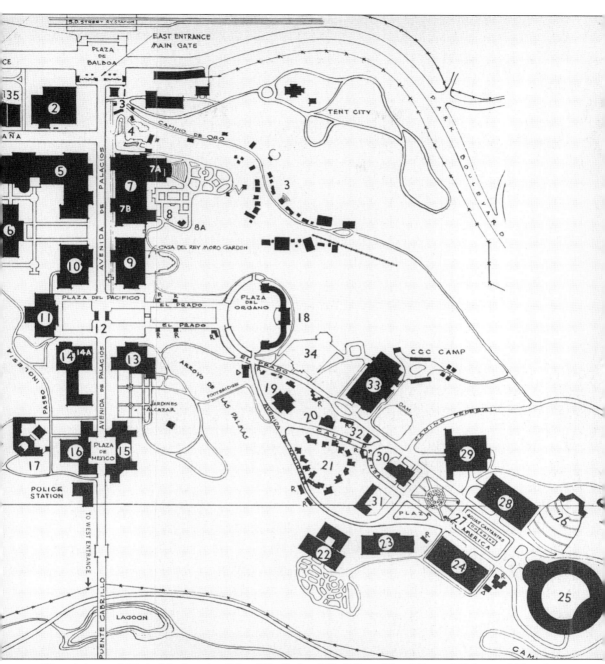

Electricity and Varied Industries (No. 28), Federal Building (No. 29), and Palace of Travel, Transportation, and Water (No. 33). On the left, the former Isthmus fun zone has been revamped and renamed the Midway (No. 44). "Zocalo" is the name of the street. The 1915 Painted Desert exhibit remains, this time called the "Indian Village" (No. 45). Only two years after it was first conceived, the 1935 California Pacific International Exposition opened on May 29, 1935, and, like the first Balboa Park exposition, its success led to a second year.

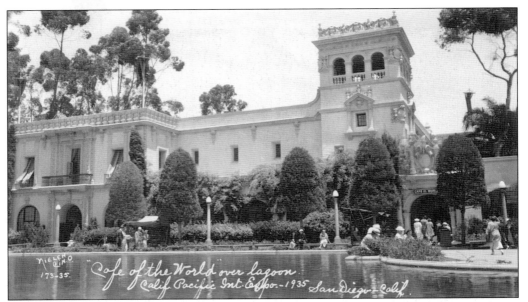

CAFE OF THE WORLD. The former Home Economy Building/Pan-Pacific Building was renamed the Café of the World in 1935. The café seated 850 guests who could order dishes typical of various countries of the world like French, Italian, Spanish, Swedish, and English. According to the *Official Guide*, "Two oval bars seventy feet long are presided over by twenty 'international' bartenders." Lobster Newburg cost $1 and a martini was 35¢.

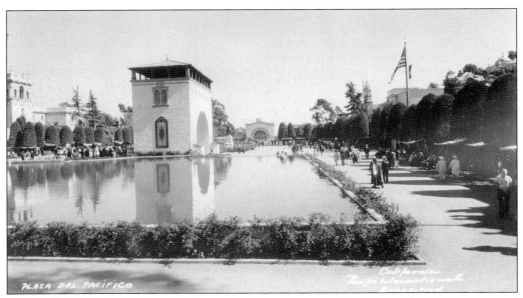

PLAZA DEL PACIFICO. The main square, christened the Plaza de Panama in 1915, was renamed the Plaza del Pacifico in 1935. The large reflecting pool in the foreground and arched tower were temporary additions to the plaza that were removed when the fair ended in 1936. The name Plaza del Pacifico never stuck, so the "great central quadrangle" continues to be known as the Plaza de Panama.

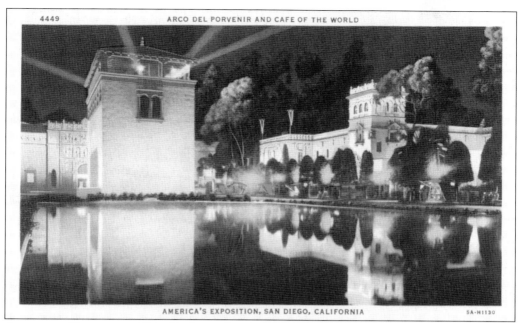

AMERICA'S EXPOSITION, SAN DIEGO, CALIFORNIA 5A-H1130

ARCO DEL PORVENIR. This 50-foot-tall arched tower was named Arco del Porvenir, which translates into "Arch of the Future." It was constructed for the 1935 exposition to house public address speakers and spotlights that projected colored light. According to the *Official Guide*, "At night [the plaza] becomes a rainbow of mirrored lights." A great deal of attention was devoted to the exterior lighting for the California Pacific International Exposition. Lighting expert H. O. Davis supervised the innovative lighting design. Davis drew inspiration from popular artist Maxfield Parrish, whose fantasy paintings often depicted deep-blue twilight scenes streaked with amber light. Davis had a design epiphany when he saw one of Parrish's paintings—not in a museum—but in a General Electric calendar hanging in his office.

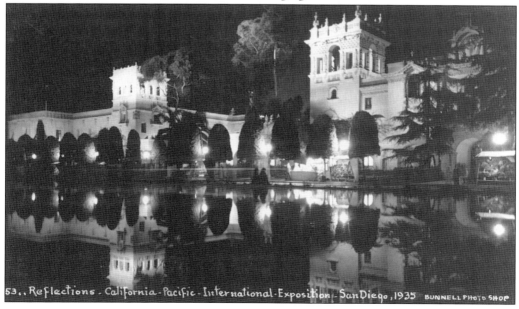

53., Reflections - California - Pacific - International - Exposition - San Diego, 1935 BUNNELL PHOTO SHOP

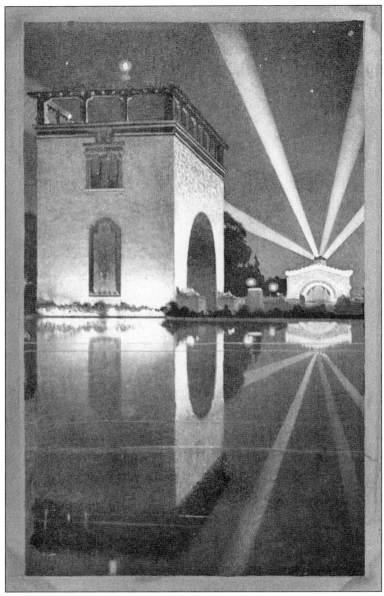

LIGHTING EFFECTS. Here is another view of the night lighting as seen from the Plaza del Pacifico looking south to the Spreckels Organ Pavilion. Exposition architect Richard Requa, working with H. O. Davis and Hollywood lighting engineer Otto K. Olesen, wanted to create layered and silhouetted effects with the exterior lighting. Instead of simply pointing lights at the building facades, colored lights were directed at the landscaping in front of the buildings. Violet, blue, red, and green lights were used to "paint" palms, bougainvillea, and other landscape features. Soft ambers were used to wash the building facades, while blue and red floodlights internally lit the open-air towers. The 1935 *Official Guide* stated, "The lighting experts of America's Exposition have created the world's greatest nocturnal spectacle in illumination. Even the stars shine more brightly for the rivalry." The "aurora borealis" rotating light beams visible on top of the Organ Pavilion provided a dramatic light show that could be seen for miles.

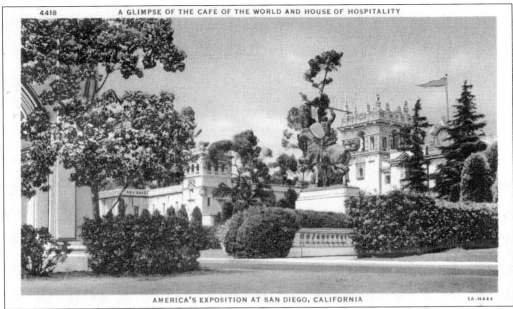

AMERICA'S EXPOSITION AT SAN DIEGO, CALIFORNIA 5A-H444

ARTISTIC LICENSE. Photograph manipulation did not begin with the invention of computer photograph editing software. A comparison of these two postcard images clearly shows how, even in 1935, a photograph is only the beginning of the process. The most common alterations to postcards, aside from the coloring, are the addition of picturesque clouds. The examples on this page take photograph manipulation to a new level. The bottom image has been altered by adding the Clydesdale team and widening the road, but even the top image was modified to include a flag on the upper right. Even though Wilson and Company had a Clydesdale horse team and wagon, they were not a brewery—they were a meatpacking company. Apparently associating horses with meatpacking was not viewed as a problem at the time.

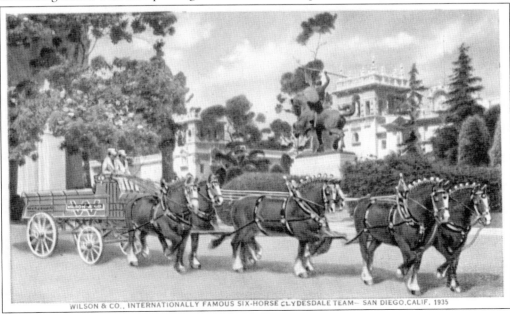

WILSON & CO., INTERNATIONALLY FAMOUS SIX-HORSE CLYDESDALE TEAM— SAN DIEGO, CALIF. 1935

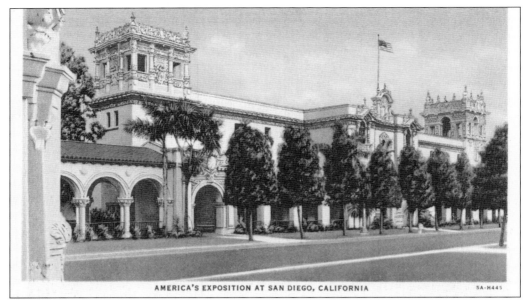

HOUSE OF HOSPITALITY. The renamed Foreign Arts Building was where visiting notables were received and entertained in the Sala de Oro and other reception rooms. The building provided offices for San Diego mayor Percy Benbough, exposition president Frank G. Belcher, staff, and several fraternal organizations. A first-aid station was located where the visitors' center is now housed.

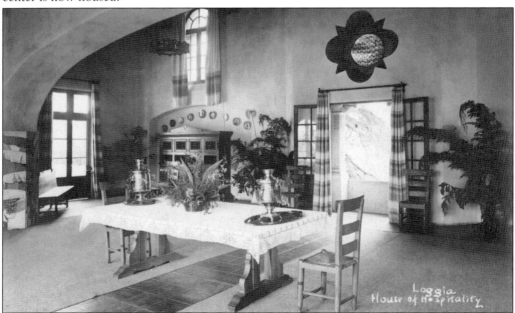

HOUSE OF HOSPITALITY, LOGGIA. This rare interior view of the House of Hospitality's second-floor Loggia shows where first lady Eleanor Roosevelt was the guest of honor at a lunch on October 2, 1935. Pres. Franklin D. Roosevelt dined one floor below in the Sala de Oro, now a restaurant bar. The 1997 reconstruction included the accurate recreation of the light fixtures and curtains seen here.

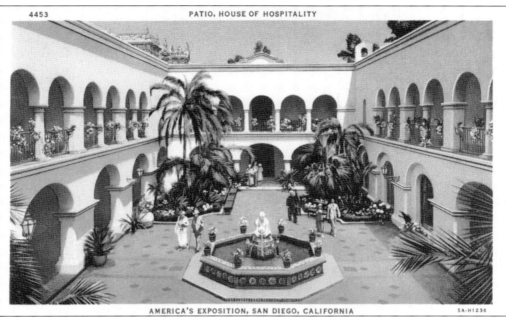

AMERICA'S EXPOSITION, SAN DIEGO, CALIFORNIA SA-H1236

HOUSE OF HOSPITALITY, PATIO. These postcards show day and night views of the popular patio that was created for the 1935 exposition. Architect Richard Requa literally carved out the center of the hangar-like 1915 Foreign Arts Building and opened it to the sky. Remnants of the original heavy-timber trusses that once spanned over the patio can still be seen above the second-floor arcades. The design of the patio was inspired by the patio of the Convent of Guadalajara in Mexico. The central tile fountain is topped by a limestone figure known as the "Woman of Tehuantepec," carved by renowned sculptor Donal Hord. Requa also added the second floor, along with elaborate interior finishes and decorations. Exposition art director Juan Larrinaga, a Hollywood studio designer, played a key role in the design of stencils and light fixtures throughout the fairgrounds.

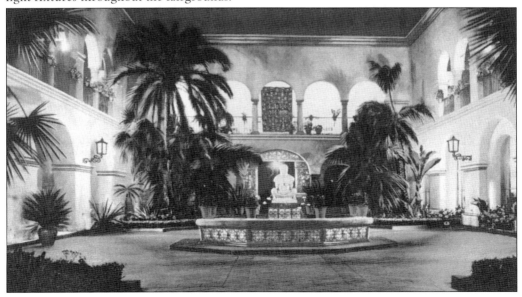

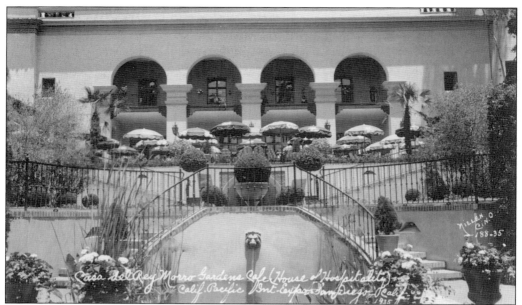

CASA DEL REY MORO GARDENS. In 1915, the Foreign Arts Building (House of Hospitality) originally had a large wing on the south side, but it was removed prior to the 1935 exposition. In its place, architect Richard Requa designed the Casa del Rey Moro Gardens, a faithful reproduction of an 18th-century garden with the same name in Rhonda, Spain. The "House of the Moorish King" gardens had brick-paved terraces containing three distinct water features, wrought-iron rails, redwood pergolas, rose gardens, a well, and carefully manicured trees and shrubs. The Casa del Rey Moro Restaurant became known as the Café del Rey Moro after the exposition ended. The popular Mexican restaurant continued serving food until 1994. In 2007, the Prado Restaurant serves meals and provides catering for the many weddings and events held in this picturesque garden.

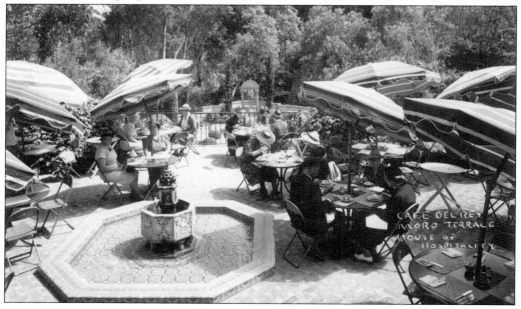

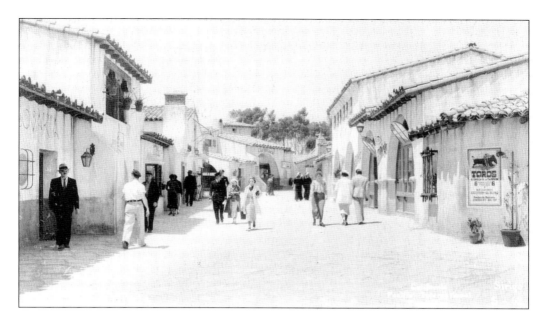

SPANISH VILLAGE. Early plans for the 1935 exposition called for several international "Villages of the World" to house foreign exhibits. Villages were planned for Germany, Italy, the Orient, Russia, France, and Mexico. Spanish Village was the only one to be constructed. The village included winding streets with restaurants, the Laguna Shop of Color featuring handmade pottery, and shops with jewelry, flowers, wine, and art. The whitewashed, red tile-roofed buildings were meticulously detailed and landscaped to create the illusion of old Spain, down to posters for fictitious bullfights. In 1937, the Spanish Village was reopened by artists who created what is now known as the Spanish Village Art Center. Unfortunately, the addition of garish paint colors appear more like contemporary Mexico than old Spain.

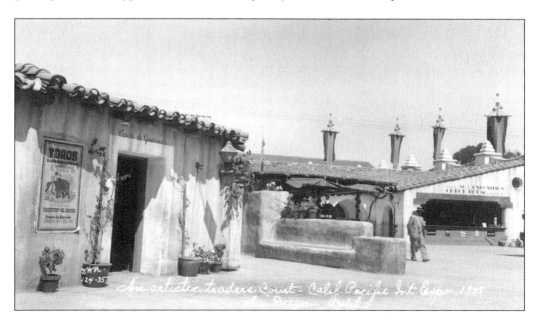

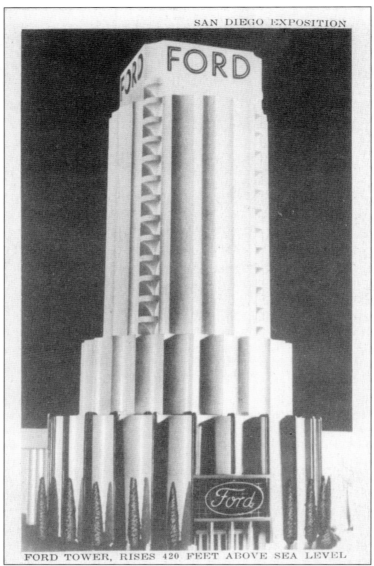

FORD

FORD

Ford

FORD TOWER, RISES 420 FEET ABOVE SEA LEVEL

FORD TOWER. Modeled after the Ford Motor Company's building at the 1933 Chicago Century of Progress Exposition, designed by architect Albert Kahn, this structure is one of the rare "modern" buildings erected in the park. Well-known industrial designer Walter Dorwin Teague used Kahn's earlier design as the source for Balboa Park's Ford Building. This early rendering shows the original design of the structure, complete with a telescoping tower that topped out at 198 feet (or more impressively "420 feet above sea level"). Such a tower would have rivaled Goodhue's 1915 California tower. Architects Richard Requa and Louis Bodmer oversaw the design and construction, which proved to be an immense challenge due to an extremely short construction schedule. After the drawings were complete, the Ford Motor Company abruptly decided to shrink the building. According to Requa's account in his 1937 book, the "seemingly impossible" task of trying to complete the Ford Building on time created in him "an overwhelming desire to wander off into a peaceful glade in the Park, fall asleep and forget it all."

86

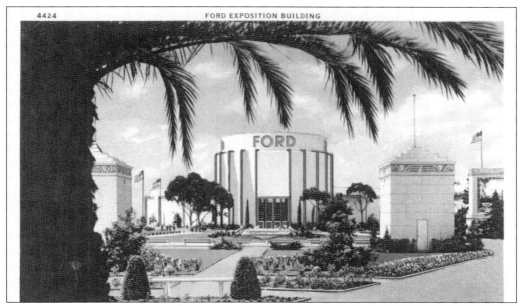

FORD BUILDING. The Streamline Moderne design of the Ford Building recalls a stack of automobile gears. The vertical ribs were dramatically backlit with blue neon and the name "FORD" appeared in red neon on all four sides of the main rotunda. Exhibits inside included a mock assembly line, examples of Ford cars since 1896, and the mighty V–8 engine. On the walls inside the building were 12 colored dioramas that gave a picture story of the production of various materials used in the manufacture of Ford cars. A large, open-air courtyard in the center of the building contained the latest Ford models around a large fountain shaped like the V–8 logo. The Ford Building has housed the San Diego Air and Space Museum (formerly Aerospace Museum) since 1980. The gardens and fountain in front of the building were replaced by a parking lot after the exposition.

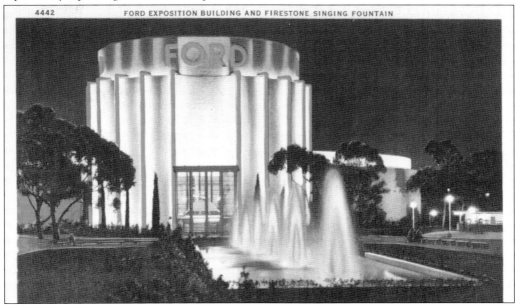

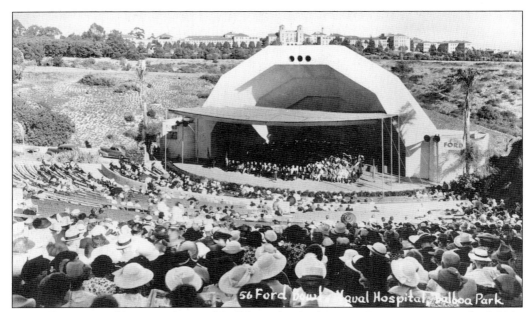

FORD BOWL. In addition to the Ford Building, the Ford Motor Company sponsored a 3,000-seat, open-air amphitheatre next door. The Ford Bowl was the venue for a wide variety of musical performances during the exposition, including choirs and symphonies. The structure later became known as the Starlight Bowl, operated by the San Diego Civic Light Opera. Despite a clumsy expansion, the amphitheatre shell remains.

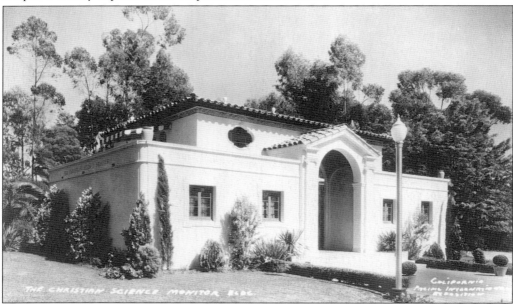

CHRISTIAN SCIENCE MONITOR BUILDING. This modest structure was built near the House of Pacific Relations. The $20,000 building contained a Christian Science reading room, a display of the history of Christian Science, and writings of founder Mary Baker Eddy. After the exposition, the Christian Science Monitor Building was renamed the United Nations Building and remains standing in 2007.

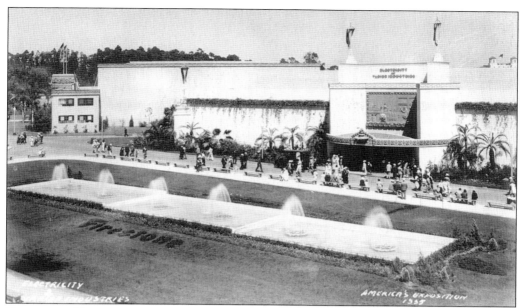

PALACE OF ELECTRICITY AND VARIED INDUSTRIES. The most talked about aspect of this building was the House of Magic, a display of electricity marvels sponsored by General Electric. The Plaza de America, in front of the building, contained the Firestone Singing Colored Fountains. The 20-foot-wide by 120-foot-long pool contained jets of water colored with light that would rise and fall to music. The Palace of Electricity is now the Municipal Gymnasium.

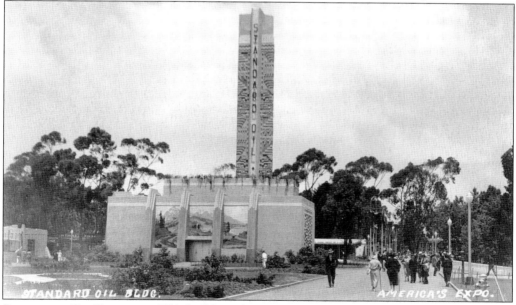

STANDARD OIL BUILDING. This building, featuring the 108-foot-high Tower of the Sun, was located at the north end of the Plaza de America. The elaborate ornamentation used designs inspired by prehistoric palaces in Mexico and the Yucatan. In their souvenir program, Standard Oil modestly states, "Particularly notable within the building is the lack of commercialism, the whole of the exhibit being devoted to the story of the National Parks of the West."

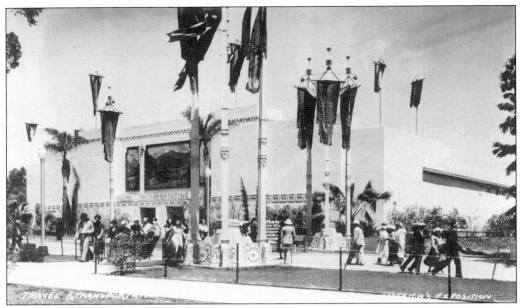

PALACE OF TRAVEL, TRANSPORTATION, AND WATER. This building was located between the Organ Pavilion and the Federal Building. The entrance to the Travel and Transportation portion was on the northwest side (top). One of the exhibits was a miniature working model of the Santa Fe Railroad between San Diego and Chicago. This exhibit was a precursor to the current San Diego Model Railroad Museum in the Casa de Balboa. The Water Palace (bottom) had a separate entrance facing the rear of the Organ Pavilion, complete with a huge spout that poured water on either side of the entrance. According to the *New York Times*, the Water Palace exhibits "told the story of man's fight for the 'white gold' of the semi-arid West." The Palace of Travel, Transportation, and Water was demolished after the exposition to make room for a parking lot.

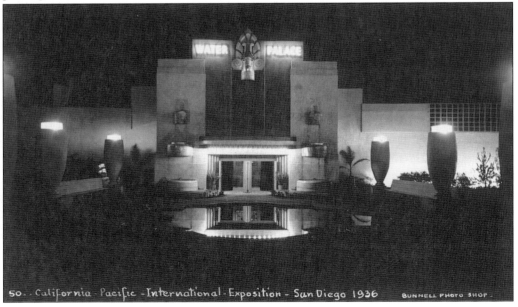

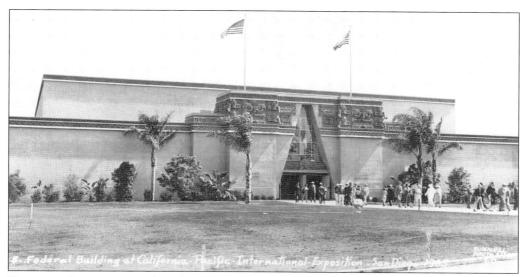

FEDERAL BUILDING. Built to house exhibits of the United States government, the Federal Building was decorated in a Mayan motif. The triangular-shaped entrance was modeled after the doorway to the Governor's Palace in Uxmal, Yucatan. The large entrance window was painted with a mural of a standing Maya priest and a crouching Native American. In 2000, the building was restored and became the home of the Hall of Champions sports museum. Unfortunately, the colorful window mural was not recreated.

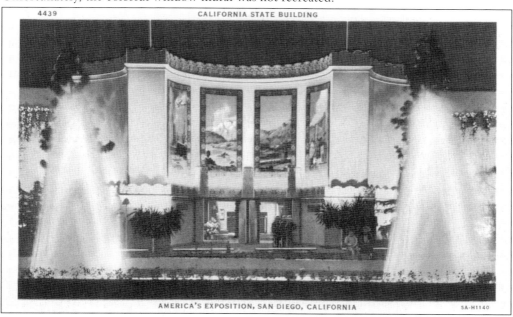

CALIFORNIA STATE BUILDING. Not to be confused with the California Building of the 1915 exposition, this simple structure was built in 1935 adjacent to the Ford Building. In this view, four large murals are visible on the curved wall above the main entrance. Inside the building, according to the *Official Guide*, 100-foot-long murals depicted "the lore of the golden state since the days of the padres and old missions." In 1988, the San Diego Automotive Museum opened in the building.

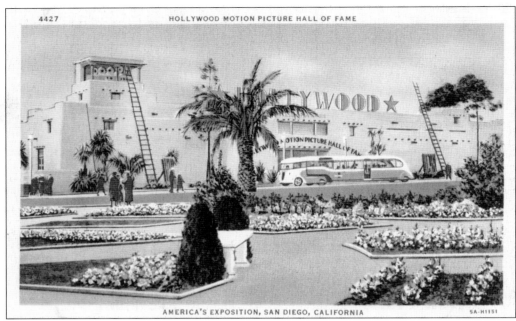

AMERICA'S EXPOSITION, SAN DIEGO, CALIFORNIA 5A-H1151

HOLLYWOOD MOTION PICTURE HALL OF FAME. In 1935, this new, pueblo-style building had exhibits demonstrating "how modern talking motion pictures are made." Visitors could peer into a sound stage where "a lively scene is rehearsed, lighted, directed and shot." There was also a children's show featuring puppets. Now called the Palisades Building, the structure houses a 300-seat recital hall, offices, and the Marie Hitchcock Puppet Theater.

PALM CANYON BRIDGE. A ravine south of the House of Charm (Indian Arts Building) was named Arroyo de Las Palmas, or Palm Canyon, in 1915. In 1936, a visitor from London enthused, "I believe that the view of Palm Canyon under the glow of the many colored lights is one of the most beautiful in the world." The rustic log bridge was lit from above by bell-shaped lanterns perforated with colored glass beads, seen in the center of this image.

HOUSE OF PACIFIC RELATIONS. Despite the name, there was not just one House of Pacific Relations—there were more than a dozen Spanish-style cottages representing 21 nations. As described in the 1935 *Official Guide*, "Floral patios, winding walks, rock gardens and pools make it one of the most attractive sites in America's Exposition grounds." Participating countries included the British Empire, China, Italy, Denmark, Cuba, Norway (top), Chile, Yugoslavia, Panama, and Argentina among others. Historic photographs show the incongruous German swastika flag and rising sun flag of Japan (bottom) displayed on houses dedicated to "international peace" only three years prior to the start of World War II. In 2007, thirty-one nations open their doors to the public every Sunday afternoon, continuing Balboa Park's tradition of multicultural goodwill and understanding.

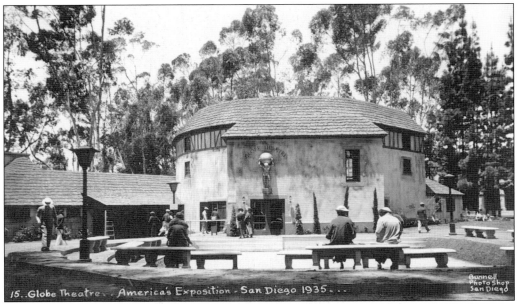

15..Globe Theatre. America's Exposition - San Diego 1935...

Bunnell Photo Shop San Diego

OLD GLOBE THEATRE. The Old Globe Theatre was constructed in 1935 to present 45-minute versions of Shakespeare's plays. The theater seated 350 persons on wooden benches for 25¢ apiece. The building was modeled after Shakespeare's Elizabethan-style London theater, constructed in 1599. The Old Globe complex included an Old Curiosity Shop where one could purchase English pottery, silver, and imported curios and Falstaff's Tavern, described as "the only authentic English Tavern on the Coast." Like the buildings of the 1915 exposition, the Old Globe was intended to be a temporary structure. In 1936, the theater was sold to wreckers for $400, but a citizen's committee was organized and raised funds to save the building. During World War II, the navy used the theater complex as a lecture hall, and the box office was used as a barber shop. Below the "Queen" surveys a dance performance.

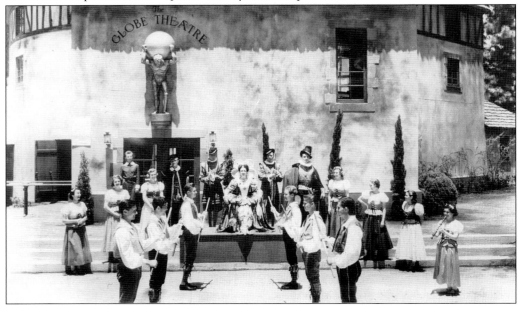

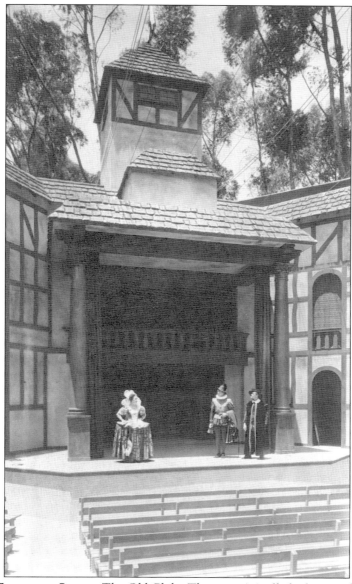

OLD GLOBE THEATRE, STAGE. The Old Globe Theatre originally had no roof over its center, to replicate the original in London. But the top was covered with canvas after only a few weeks. On March 8, 1978, an arson fire destroyed the Old Globe Theatre. In order to provide a temporary venue for the summer season, a 615-seat outdoor Festival Stage was constructed in just 100 days. The new Old Globe Theatre was dedicated in 1982 and bore only a passing resemblance to what was built in 1935. In 1984, another tragic fire destroyed the Festival Stage. It too was reconstructed and was rededicated the Lowell Davies Festival Theatre. The third stage at the Old Globe is the Cassius Carter Centre Stage, built in 1968 where the Falstaff Tavern was once located. The current Old Globe Theatre is widely recognized as one of the finest regional theaters in the country. Many Hollywood luminaries made their mark in Balboa Park, including Dennis Hopper, Marsha Mason, Jon Voight, Christopher Reeve, Marion Ross, John Goodman, and Christopher Walken.

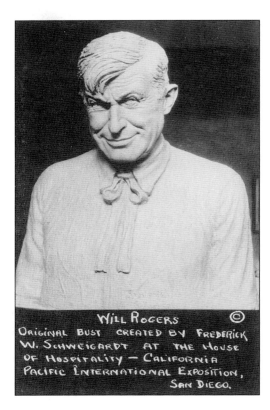

WILL ROGERS
ORIGINAL BUST CREATED BY FREDERICK
W. SCHWEIGARDT AT THE HOUSE
OF HOSPITALITY — CALIFORNIA
PACIFIC INTERNATIONAL EXPOSITION,
SAN DIEGO.

EXPOSITION ARTISTS. Sculptors have had an important role in creating the look of Balboa Park. In 1915, teams of European-trained sculptors molded the ornate facades of the exposition buildings. In 1935, artisans sculpted intricate Mayan designs for several Palisades buildings. The House of Hospitality was home to exhibit designers and sculptors during the 1935–1936 exposition, including Frederick W. Schweigardt. Schweigardt created a bust of Will Rogers (left), the cowboy-humorist who died in a plane crash in 1935. Schweigardt also sculpted a fountain called *The Four Cornerstones of American Democracy* (bottom) inside the Palace of Education, originally the New Mexico Building. Female figures represent home, church, school, and community. The building is now called the Balboa Park Club. *The Four Cornerstones* sculpture remains, but the fountain is dry.

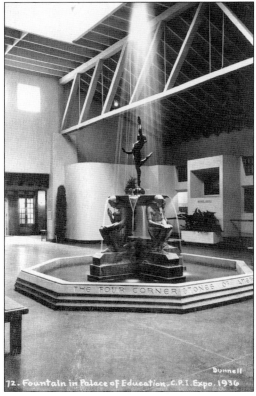

72. Fountain in Palace of Education. C.P.I. Expo. 1936

Seven

FUN ZONE

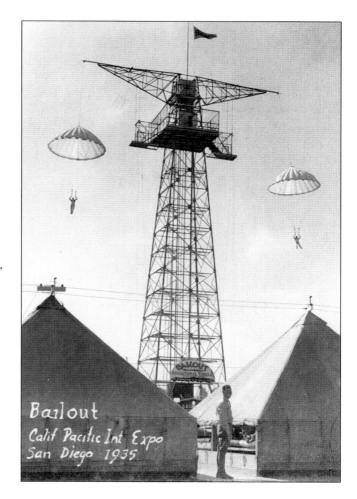

PARACHUTE DROP, 1935.
Today there is bungee jumping,
but in 1935 Balboa Park had
this ride called Bailout. Riders
would free-fall from a 155-
foot steel tower attached to
a parachute and steel cable.
The Russian military had
been using similar towers
to train paratroopers since
the 1920s. The text on
the sign reads, "First time
presented in America. Get
the thrill of a lifetime!" A
larger Parachute Jump was a
popular attraction at the 1939
New York World's Fair.

Bailout
Calif Pacific Int Expo
San Diego 1935

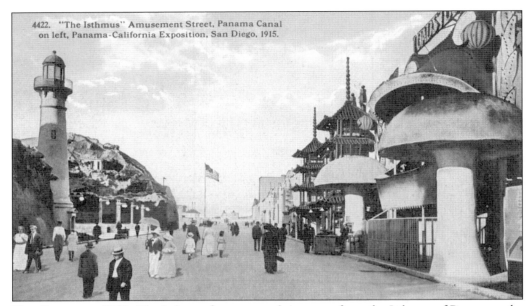

4422. "The Isthmus" Amusement Street, Panama Canal on left, Panama-California Exposition, San Diego, 1915.

THE ISTHMUS, 1915. The Isthmus fun zone took its name from the Isthmus of Panama—the narrow strip of land between the Pacific Ocean and the Caribbean Sea. Promoters touted the Isthmus as "the best array of entertainment features ever assembled." On the right is a ride called The Toadstool, which had a spinning disc that challenged riders to keep their balance. On the left is a lighthouse "with a real beacon" that attracted fairgoers to the Isthmus.

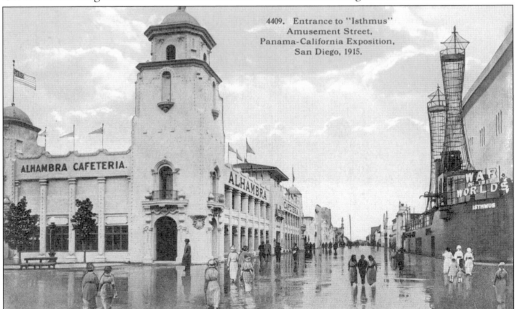

4409. Entrance to "Isthmus" Amusement Street, Panama-California Exposition, San Diego, 1915.

THE ISTHMUS, 1915. The Alhambra Cafeteria was billed as "the largest cafeteria in the world," with seating for 1,200. It featured Coronado Clam Chowder for 10¢ and Roast Belgian Hare for 35¢. The building on the right housed the War of the Worlds exhibit with "an imaginative portrayal of possible war conditions of the year 2000." Ads were quick to point out that the exhibit "does not depict the horrors of war, but is a most impressive and thrilling argument for peace."

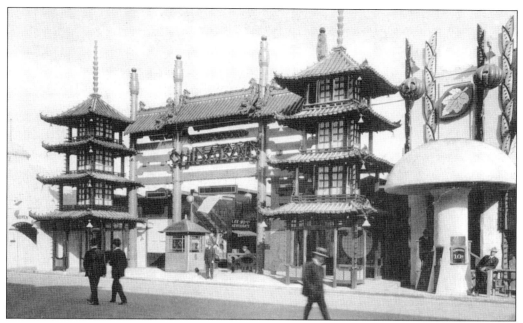

CHINATOWN, 1915. The Chinatown attraction featured an underground opium den where wax figures showed the horrors of addiction. Apparently the organizers of the exposition had second thoughts about this subject matter and conducted some damage control. *The Exposition Beautiful* picture book noted that the Chinatown attraction "is not a fair representation of the Chinese people in America" and "what it represents has largely passed away."

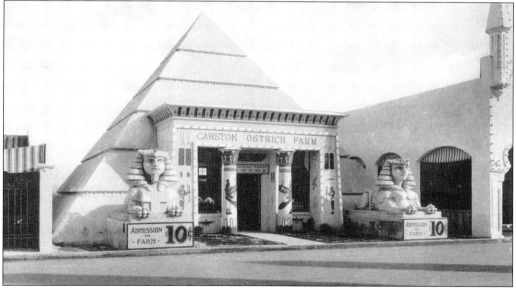

CAWSTON OSTRICH FARM, 1915. One of the places that exposition visitors could see exotic animals was at the Cawston Ostrich Farm. The building was modeled after an Egyptian pyramid, probably due to the fact that ostrich feathers were a prominent symbol in ancient Egyptian artwork. For 10¢, visitors could see the flightless birds up close and admire "an alluring and endless variety of feathers to tempt purchasers."

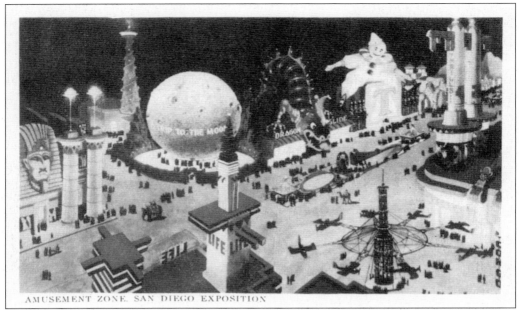

AMUSEMENT ZONE, SAN DIEGO EXPOSITION

AMUSEMENT ZONE, 1935. This early rendering of the 1935 Amusement Zone—also called the fun zone or midway—shows attractions and rides that were never built, such as A Trip to the Moon and the Dragon Slide. Both the 1915–1916 Isthmus and the 1935–1936 Midway occupied the northern part of the fairgrounds. That area is now the parking lot for the San Diego Zoo.

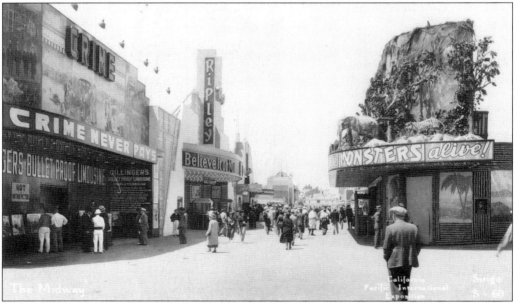

THE MIDWAY, 1935. Some of the 1935 exhibits included Crime Never Pays, which displayed bank-robber John Dillinger's bulletproof limousine complete with machine gun portholes. According to the *Official Guide*, the Monsters Alive attraction displayed "reptiles of various descriptions from all parts of the world, including giant pythons . . . and venomous cobras." The Ripley's Believe It or Not Odditorium can also be seen.

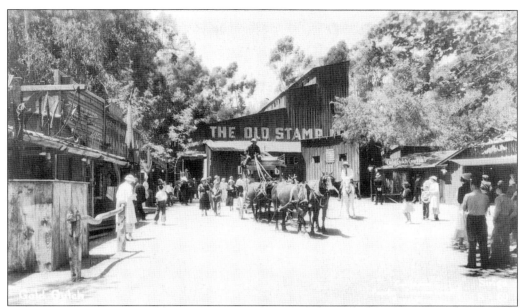

GOLD GULCH, 1935. This 21-acre mining town was located in the canyon behind the Palace of Better Housing (Casa de Balboa). The *Official Guide* referred to Gold Gulch as "a faithful 'movified' version of the pioneering period." Also faithful to the old West was stripper Gold Gulch Gertie, who was arrested for riding naked through Gold Gulch on a burro. Gertie was eventually acquitted and rode again—with police supervision. The Japanese Friendship Garden now occupies this site.

GOLD GULCH CALABOOSE, 1935. As the reader might have guessed, "Calaboose" is a slang term for a jail or prison. These two unidentified gentlemen were simply Gold Gulch visitors posing for their own photograph postcard. This card was never mailed; it was glued into a scrapbook. One-of-a-kind custom postcards were popular keepsakes from both expositions. In 1915–1916, the most popular pose was among the pigeons on the Plaza de Panama.

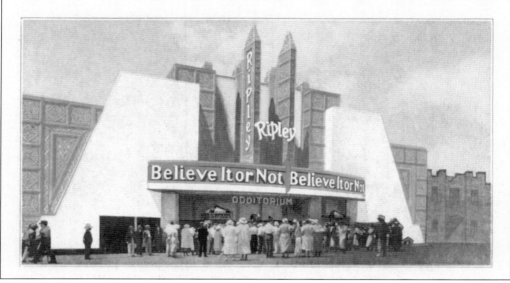

RIPLEY'S BELIEVE IT OR NOT, 1935. Fresh from the 1933 Chicago Century of Progress Exposition, Ripley's Believe It or Not built an Odditorium on the Midway in Balboa Park. Robert Ripley began as a cartoonist and writer, and his newspaper cartoons displayed all things strange, exotic, and unbelievable. In 1936, the Strange as it May Seem theater replaced Ripley's sometimes gruesome Odditorium with what an exposition press release described as a "more glamorous spectacle."

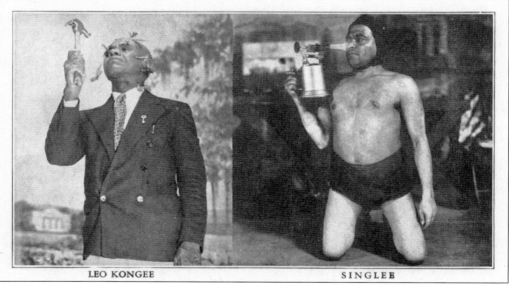

LEO KONGEE SINGLEE

RIPLEY'S LEO KONGEE AND SINGLEE. The following descriptions are excerpts from an official Ripley's pamphlet, "Leo Kongee: The Human Pin-Cushion. This man's skin never bleeds . . . he seems to be immune to torture . . . and [he] drives nails into his head." As for Singlee, "This native of Solon, India believes that he cannot be burned or harmed by fire . . . he passes a glowing blow-torch back and forth across his body."

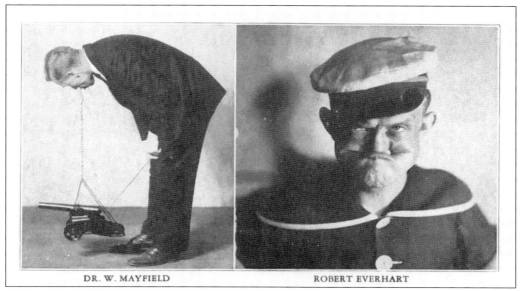

DR. W. MAYFIELD | ROBERT EVERHART

RIPLEY'S DR. W. MAYFIELD AND ROBERT EVERHART. Dr. W. Mayfield "discovered he had unusual strength in his tongue . . . he suspends a 17-pound cannon and discharges it with 10-gauge shotgun shell." Robert Everhart was "the man of many faces . . . [who] studied art at Yale . . . performs almost unbelievable facial contortions, such as touching his nose with his lower teeth, and swallowing his own nose."

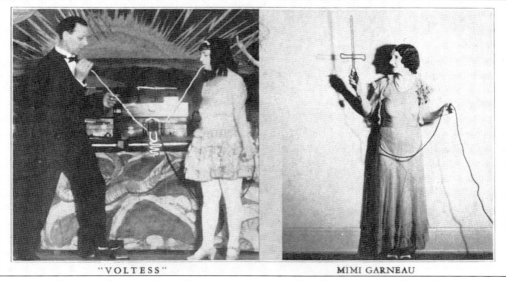

"VOLTESS" | MIMI GARNEAU

RIPLEY'S "VOLTESS" AND MIMI GARNEAU. Irene "Voltess" Battley was "the Girl Who Defies Electricity . . . is able to take 750,000 volts of electric current, . . . lights torches with her tongue, . . . and illuminates a neon sign by holding the electroids [sic] in her mouth." About Mimi Garneau, the pamphlet states, "From the time she was a little girl she has been able to swallow many long objects, such as swords and canes . . . and a lighted neon tube 22 inches long."

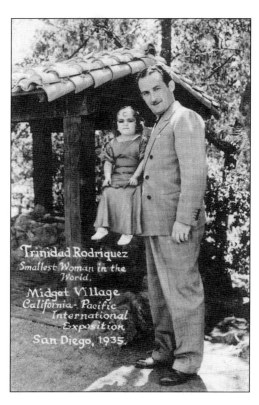

Trinidad Rodriquez
Smallest Woman in the World.

Midget Village
California- Pacific
International
Exposition
San Diego, 1935.

MIDGET VILLAGE. The 1935 exposition included many unique attractions, some more exploitative than others. The Midget Village and Midget Farm, "Built on doll-house scale," were billed as "the world's greatest aggregation of little people" and displayed "more than one hundred Lilliputians [at] work and play." In this image, 19-year-old Trinidad Rodriguez poses with Nate Eagle, the sideshow promoter who, with partner Stanley R. Graham, created Midget Village and its predecessor at Chicago's 1933 fair.

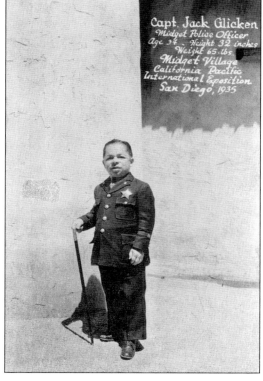

Capt. Jack Glicken
Midget Police Officer
Age 34 - Height 32 inches
Weight 65 lbs.
Midget Village
California Pacific
International Exposition
San Diego, 1935

MIDGET POLICE OFFICER. Midget Village had, according to *Radio Talk*, "A completely organized civic administration with a mayor, chief of police and fire department." In this image, Capt. Jack Glicken poses as a midget police officer. Many of the little people from the 1935 California Pacific International Exposition went on to greater fame in the classic 1939 film *The Wizard of Oz* portraying Munchkins and winged monkeys. Jack Glicken portrayed one of the "Singer Midgets" in the film.

MINIATURE "MAE WEST." Eleanor Stubitz dresses as a smaller version of screen icon Mae West in this postcard view. Many of these postcards were autographed by the subjects on the back. Along with her signature, Eleanor added this information, "Age 20 height 40 in. weight 45 lb. born in Chicago, Ill." The residents of Midget Village ranged in age from 18 to 60 years and included dancers, singers, artists, and craftsmen.

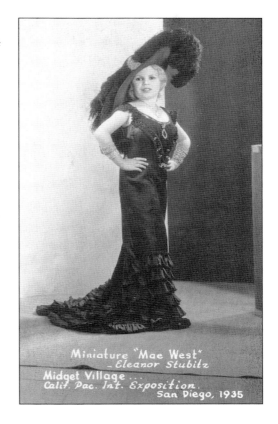

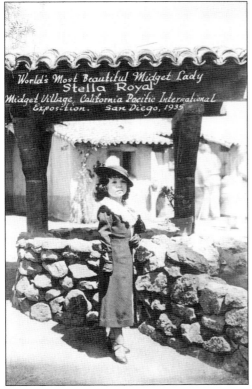

BEAUTIFUL STELLA ROYALE. Twenty-two-year-old Stella Royale (her last name is misspelled on this postcard) also had a role in *The Wizard of Oz*. During Children's Day at the exposition, Jack Dempsey, former world's heavyweight boxing champion, refereed a bout between two midget boxers. For the second year of the exposition, Midget Village was replaced by the Mickey Mouse Circus, where midgets sang and performed with full-size elephants.

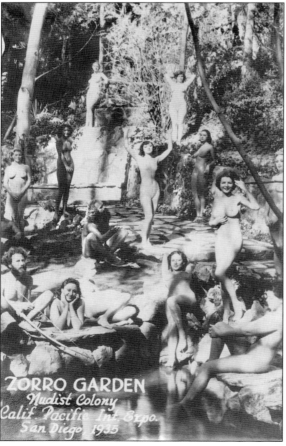

ZORRO GARDEN
Nudist Colony
Calif. Pacific Int. Expo.
San Diego 1935

ZORO GARDENS, 1935. In addition to Midget Village, Graham and Eagle created the scandalous Zoro Gardens nudist colony. Located in a sunken garden east of the Palace of Better Housing (Casa de Balboa), Zoro Gardens (misspelled "Zorro" at left) was, according to the Zoro Gardener, "Designed to explain to the general public the ideals and advantages of natural outdoor life." Topless women and bearded men in loincloths read books, sunbathed, and acted in pseudo-religious rituals to the Sun God. According to the program, "Healthy young men and women, indulging in the freedom of outdoor living in which they so devoutly believe, have opened their colony to the friendly, curious gaze of the public." The public's curious gaze quickly turned Zoro Gardens into the exposition's most lucrative outdoor attraction. Despite protests, Zoro Gardens lasted for the entire run of the exposition. The area is now the Zoro Butterfly Garden.

Eight

GROWING PAINS

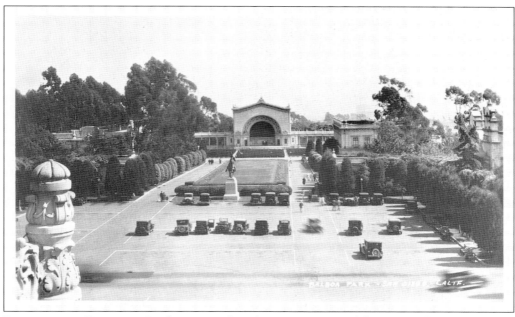

PARKING DE PANAMA. In the years after the 1935–1936 California Pacific International Exposition, Balboa Park has seen new tenants and buildings crop up and has suffered through periods of neglect and demolition. One of the most dramatic changes has been the increasing dominance of the automobile. In this image, taken from the roof of the Fine Arts Gallery in the early 1930s, one can see how cars had already taken over the Plaza de Panama.

107A:—DAHLIAS AND CANNAS, BALBOA PARK, SAN DIEGO, CALIF.

VANISHING GARDENS. In 1915, the area behind the Spreckels Organ Pavilion was undeveloped. For the 1935 exposition, this area was turned into the California Gardens. The top view shows the gardens in full bloom. Sometime after the conclusion of the exposition in 1936, the gardens were replaced by asphalt paving in order to provide much-needed parking. The bottom image shows the Casa del Rey Moro Gardens behind the House of Hospitality in the 1950s. Note that the middle terrace once had rose bushes flanking the center walkway. In the mid-1980s, the roses were removed by the restaurant and replaced with concrete in order to better accommodate special functions and weddings.

California Tower, Balboa-Park

1960s REPLACEMENTS. An early 1960s image (top) shows the Science and Education Building just before its 1964 demolition. The loss of this building and nearby Home Economy Building to make way for modernistic expansions of the Museum of Art was extremely controversial. In 1959, *San Diego Magazine* architecture critic James Britton wrote, "The disparity of approaches on the two [new museum] wings is an esthetic crime of which no worthy Fine Arts Society would be guilty." The bottom photograph, from the late 1960s, shows the faceless wall of the Museum of Art's new sculpture court building (right). The silver lining is that the loss of the two landmarks led to greater public awareness of preservation and resulted in the formation of the Committee of One Hundred, whose mission is to preserve Balboa Park's Spanish Colonial Revival architecture.

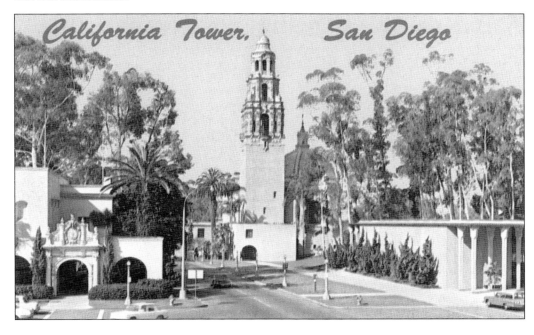

California Tower, San Diego

A Freeway Runs Through It. In addition to turning gardens into parking lots, the automobile brought a freeway into Balboa Park. State Route 163, runs through the center of Cabrillo Canyon and under the Cabrillo Bridge. The 2.5-mile stretch of freeway, with its wide landscaped median, has been called "the most beautiful parkway in the United States." It was built starting in 1942 and opened in 1948 as U.S. 395/Cabrillo Freeway. Later renumbered the 163, it was the first freeway constructed in San Diego County. The top image shows the freeway in the 1960s. Maps as late as 1953 indicate that the small 1915 "lotus pond" remained west of the freeway. The bottom image shows the freeway in the 1970s and its relationship to the exposition grounds. The Cabrillo Freeway was named an official Historic Parkway in 2003.

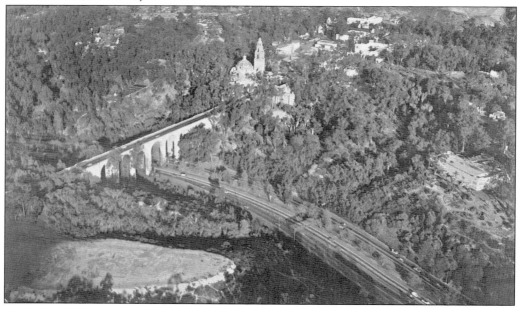

Nine

OBSCURE BALBOA PARK

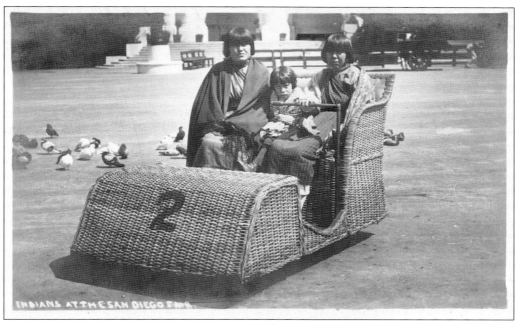

ELECTRIQUETTE, 1915. Thousands of visitors had photograph postcards taken among the pigeons while sitting in wicker cars on the plaza. Known as "Electriquettes," these custom-made, electrically powered vehicles were, according to an ad in the *Guide Book*, "The only passenger conveyance permitted" at the 1915–1916 exposition. With a top speed of 3 miles per hour, an ad enthused, "A child can drive it. It's great fun." These Native Americans were likely brought to San Diego to help populate the Painted Desert exhibit.

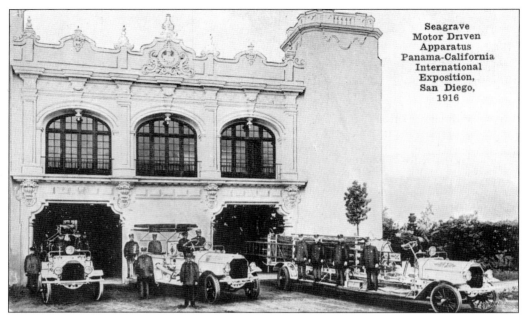

Seagrave
Motor Driven
Apparatus
Panama-California
International
Exposition,
San Diego,
1916

FIRE HOUSE, 1916. This fire station was built south of the Model Farm. The city and exposition cooperated to purchase new fire apparatus. In an effort to boost interest in the exposition, the fire department sent out 50,000 postcards like this to show off their new station. After the exposition, a fair official noted that although "the fire companies . . . stationed within the grounds responded to several alarms, the fire loss . . . did not exceed $500."

SOCCER MATCH, C. 1916. At the south end of the Panama–California Exposition was a Parade Ground and U.S. Marine Camp. This photograph, likely taken after the conclusion of the exposition, shows the Los Angeles Wanderers in a soccer match against the San Diego Nomads. The Nomads were the A.Y.C. Soccer champions in 1914. Note the exposition buildings in the background. This area is now the Palisades parking lot.

LIBERTY BELL, 1915. The famed Liberty Bell arrived in Balboa Park from Philadelphia on November 12, 1915, for a three-day visit. At the official reception, thousands of school children placed floral tributes on the bell's platform. San Diego mayor Edwin M. Capps and dignitaries from Pennsylvania took turns praising liberty. The San Diego Choral Society concluded the program by singing patriotic songs.

REVISED MAP OF CALIFORNIA, 1915. This unique comic postcard depicts a conversation between San Diego and San Francisco dismissing the modest harbor of Los Angeles as the "Butt-in-Bay." The two exposition host cities, Sandy and Frisky, joke about LA's "harborette" being so small that it cannot even keep a shark alive. It should be noted that this biting postcard was not an official exposition card, but was printed by San Diego's Old Mission Realty Company.

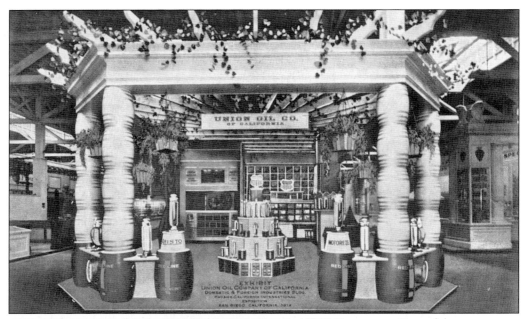

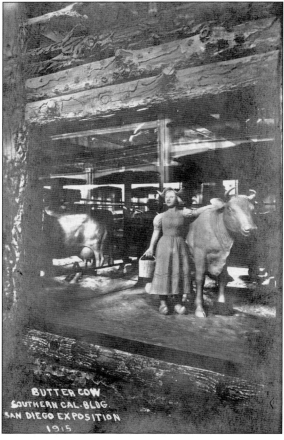

BUTTER COW
SOUTHERN CAL. BLDG.
SAN DIEGO EXPOSITION
1915

1915 EXHIBITS. One of the reasons to hold an international exposition is to exhibit the latest products from home and abroad. Curiously there are very few postcards that actually show what was being exhibited inside the various 1915–1916 exposition buildings. The top image shows the Union Oil Company exhibit in the Domestic and Foreign Industries Building (Casa del Prado). Note the exposed posts and trusses of the exhibit hall in the background. The image at left shows a cow and milkmaid sculpted out of butter in the Southern California Counties Building. Other exhibits in this building were not unlike what one would find at a typical county fair. On display were handmade crafts, a table made of 2,866 pieces of inlaid wood, hemstitched aprons, and elephants made of walnuts.

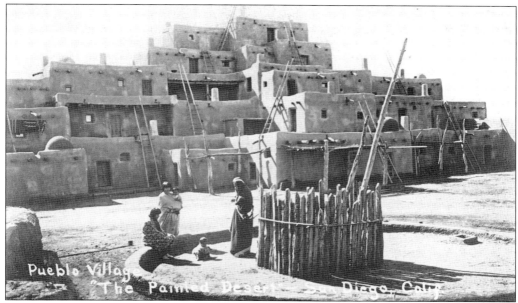

Pueblo Village "The Painted Desert – San Diego, Calif"

PAINTED DESERT, 1915. One of the most unconventional exhibits of the 1915 exposition was the Painted Desert, sponsored by the Santa Fe Railroad. The Painted Desert was promoted as "the most extraordinary exhibit of Indian life ever attempted." For 25¢, visitors could see "Pueblo Indians working and playing as they do in their real homes in Arizona and New Mexico." On opening day, the *San Diego Union* reported, "The Indians are not idle, but are at work, shaping their pottery and perfecting their rugs and blankets and metallic ornaments just as they and their ancestors have been doing for centuries. The red man, in fact, did most of the construction work, bringing with them from the neighborhood of the real Painted Desert of Arizona, the materials with which they duplicated real conditions with unfailing accuracy."

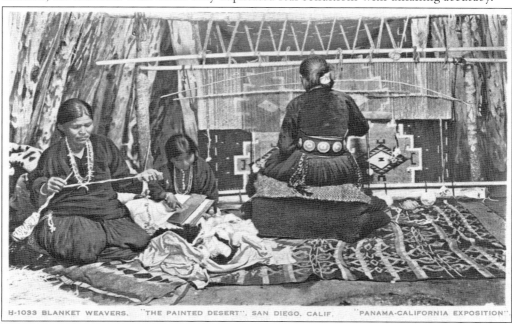

H-1033 BLANKET WEAVERS. "THE PAINTED DESERT", SAN DIEGO, CALIF. "PANAMA-CALIFORNIA EXPOSITION".

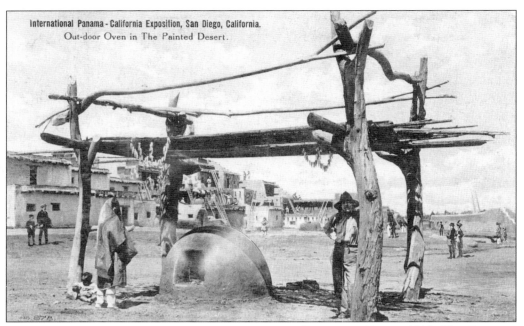

International Panama - California Exposition, San Diego, California.
Out-door Oven in The Painted Desert.

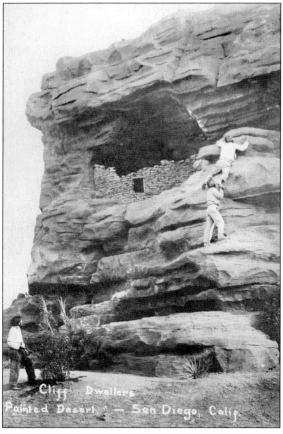

Cliff Dwellers
Painted Desert — San Diego, Calif.

OUTDOOR OVEN, 1915. The *San Diego Union* reported that the Native Americans were "reproducing [their] life so that the white man can understand it." Details of their life included "open fireplaces and bakeries, and the supports where the hay and wood are cured." Even rocks were imported from Arizona and New Mexico. The large Painted Desert exhibit was located at the extreme north end of the exposition grounds in what is now the zoo parking lot.

ROCKY BALBOA, 1915. In addition to recreating faux-adobe pueblos, the *San Diego Union* described, "An equally impressive exhibit of the life of the nomadic tribes . . . [with] the crumbling ruin of a cliff dwelling." The Painted Desert proved to be so popular it was revived for the 1935 exposition and renamed the Indian Village. Later the village was used as a Boy Scout camp before the fire marshal declared the wood–framed structures a fire hazard.

TRAVELING IN STYLE. Balboa Park has seen its share of unique vehicles. The top postcard shows a Holsman automobile that was driven to San Diego from Chicago for the 1935–1936 California Pacific International Exposition. Holsman cars were manufactured from 1901 to 1911 in Chicago. Architect Henry K. Holsman designed his namesake cars and is credited with inventing the reverse gear. The bottom image shows a stretch touring car on the Plaza de Panama *c.* 1930. Luxury car tours like this one often traveled several hundred miles to visit popular sites such as Balboa Park. Most included lodging and meals.

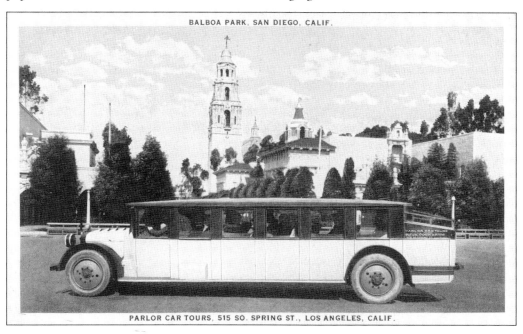

BALBOA PARK, SAN DIEGO, CALIF.

PARLOR CAR TOURS, 515 SO. SPRING ST., LOS ANGELES, CALIF.

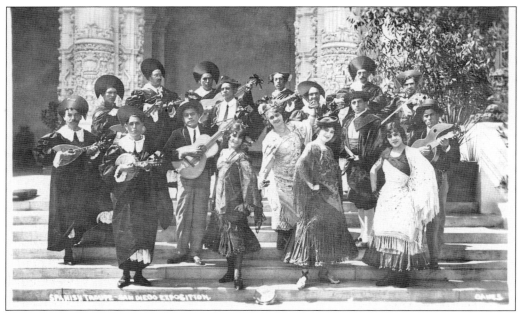

SPANISH TROUPE, 1915. To add to the Latin ambiance, organizers of both expositions hired costumed musicians and dancers. In the July 1915 issue of *Independent Magazine*, a writer observed, "About the Plaza de Panama . . . or down the Prado strolls a band of Mexican boys and girls who sing and dance and tweak their mandolins and guitars and then—just as the knot of watchers is most eager for more—wander on and away."

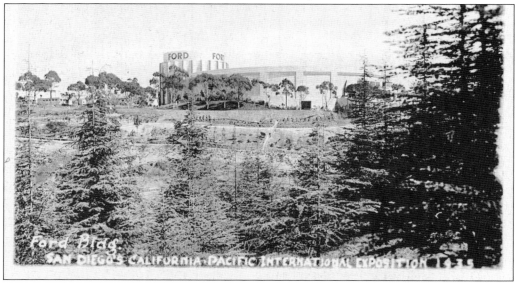

ROADS OF THE PACIFIC, 1935. Hidden behind the Ford Building, but visible in this postcard, were the "Roads of the Pacific," where fairgoers could ride in new Ford V-8 cars over a winding route along the Cabrillo Canyon. The course was modeled after 14 famously rough roads, including the Oregon Trail, China's Summer Palace Road, Peru's Inca Highway, and El Camino Real, to demonstrate the new Fords' smooth ride over bad terrain. In 2007, evidence of this road, adjacent to Interstate 5, has all but disappeared.

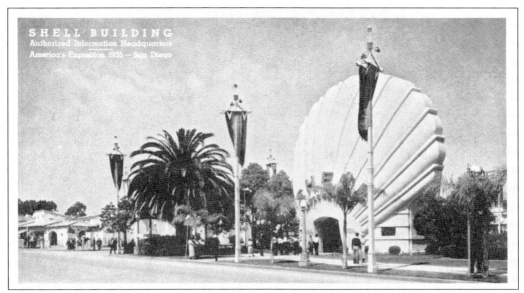

SHELL BUILDING, 1935. The Shell Oil Company was a major participant at the 1935 exposition. To promote the fair, Shell's 34,000 filling stations gave away 12-page pictorials and asked drivers if they planned to attend the San Diego exposition. Inside the fairgrounds, the oil company erected this 60-foot-tall, shell-shaped information booth, which featured a 38-foot-long map "with vari-colored neon tubes that form the principal highways of the United States."

MODELTOWN, 1935. The newly created Federal Housing Administration (FHA) sponsored an exhibit behind the Palace of Better Housing (Casa de Balboa) that consisted of a town filled with "tiny structures, standing less than 3 feet high, [each] designed by an outstanding Southern California architect." The *Official Guide* explains that "clever mechanical devices" transform "a tiny dilapidated village" into "a smart modernized group of homes before your eyes."

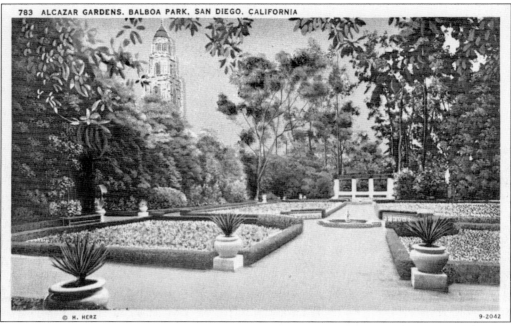

© H. HERZ 9-2042

LOOKING BACKWARD, C. 1940. This postcard shows the popular Alcazar Gardens adjacent to the House of Charm that were designed and built for the 1935—1936 California Pacific International Exposition. The original 1915 garden was called Los Jardines de Montezuma. This view is looking west toward a small pergola. If the California tower seems out of place, it is because this postcard was printed backward.

BEER GARDEN, 1935. At the north end of the Midway was the Bavarian Beer Garden. Employees of the establishment (like Max Etzkorn at left) wore authentic Bavarian costumes. The rear of this postcard featured a bawdy poem about a girl from Paris. A sample line stated, "I was working for the city, I was working in the pit, Sometimes I shoveled gravel, Sometimes I shoveled . . . SWEET violets."

Residence of G. W. Marston, San Diego, Cal.

MARSTON HOUSE. At the extreme northwest corner of Balboa Park sits the George White and Anna Gunn Marston House, designed by renowned architect Irving J. Gill. Constructed in 1905, the mansion cost $16,000 to build. Donated by Mary Marston, the 4.5-acre house and its splendid gardens have been operated as an interpretive museum by the San Diego Historical Society since 1976.

GOLF COURSE, BALBOA PARK, SAN DIEGO, CALIFORNIA—123

GOLF COURSE. Most people do not associate Balboa Park with golf. But over 21 percent of Balboa Park's 1,200 acres are devoted to the Balboa Park Municipal Golf Course. It is the oldest golf course in San Diego, built in 1921, and has an 18-hole course and a 9-hole executive golf course. Renovations were completed in 1996. The old course record belongs to Sam Snead, who shot a 60 in 1943.

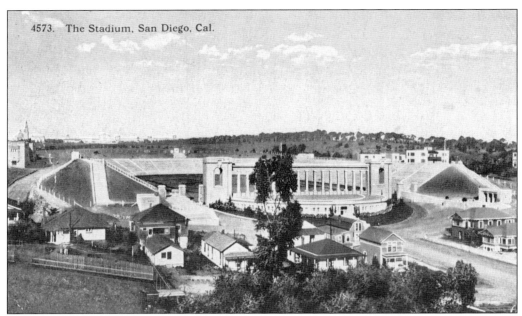

4573. The Stadium, San Diego, Cal.

BALBOA STADIUM, 1914. Originally known as "City Stadium," Balboa Stadium opened in 1914 near the southern edge of Balboa Park. It was said to be the largest municipal stadium in the country with seating for 23,000. In 1919, Pres. Woodrow Wilson made a speech here, and in 1927 Charles Lindbergh greeted well-wishers after his famous transatlantic flight. From 1961 to 1966, the stadium was the home of the AFL Chargers football team who added tiers to increase capacity to 34,000. On January 5, 1964, the Chargers throttled the Boston Patriots 51-3 in Balboa Stadium for the AFL Championship. The stadium also played host to The Beatles' only San Diego concert on August 28, 1965, the night after they met Elvis Presley in Bel Air. Tickets were priced $3.50 and $5.50. The stripped–down remnants of Balboa Stadium continue to serve San Diego High School.

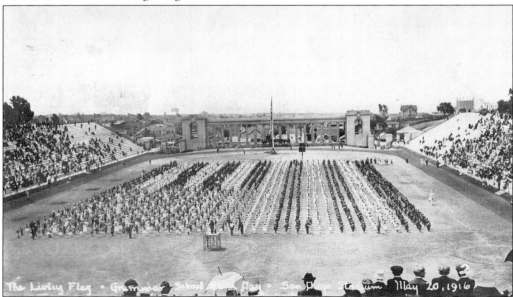

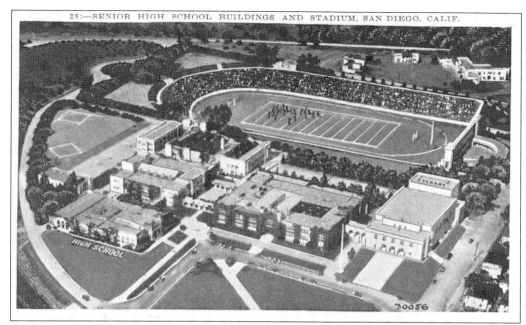

30056

SAN DIEGO HIGH SCHOOL, C. 1930. San Diego High School sits on 28 acres at the south end of Balboa Park. The top image shows the high school and its adjacency to Balboa Stadium. Established in 1882 by Joseph Russ, San Diego High School is the oldest high school in California still occupying its original site. The bottom image shows the "Grey Castle" school, built in 1907 and designed by architect F. S. Allen of Pasadena. The building was veneered in native-cut stones and had a large, central patio. Shortsighted legislation in the 1960s required all California school districts to demolish buildings constructed prior to 1933 when stricter building codes were put into effect. Subsequently, all of San Diego High School's historic buildings were systematically demolished and replaced by faceless new structures in the mid-1970s.

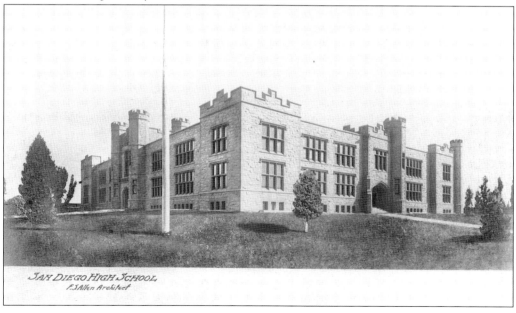

SAN DIEGO HIGH SCHOOL
F. S. Allen Architect

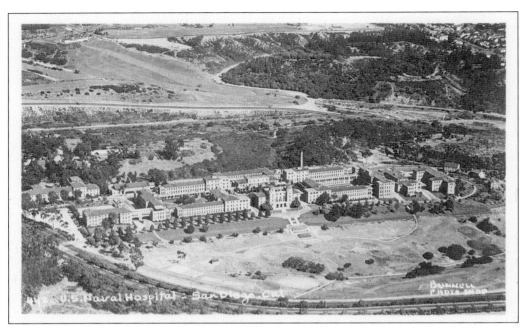

U.S. NAVAL HOSPITAL, 1922. In 1920, city voters agreed to turn over land in Balboa Park for a new navy hospital complex on Inspiration Point. The large group of buildings had stucco walls and clay tile roofs, but they were designed in a simplified Spanish style that did not compete with the 1915 exposition buildings. Not everyone was happy with parkland going to the navy. In 1929, author H. C. Hopkins wrote "Never again can San Diegans say they have a 1,400 acre park. They have nothing of the kind. They have given seventeen acres of it to the [navy]. Who will be given the next slice?" The bottom image shows the two towers of the Administration Building, the only portion of the original 1922 naval hospital that survived the 1989 demolition.

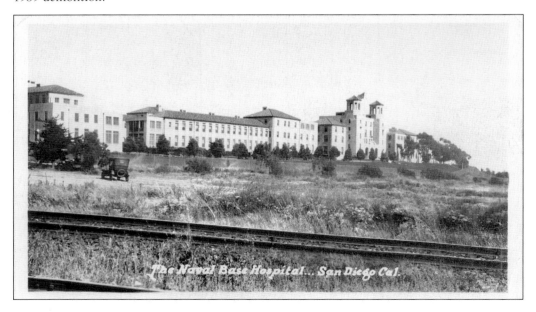

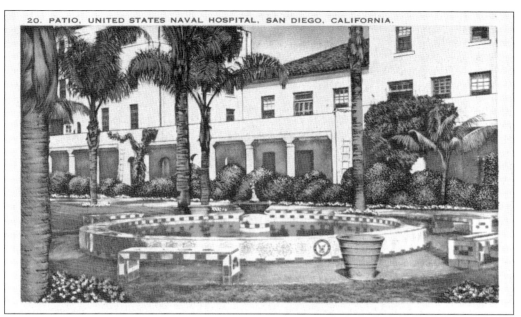

U.S. Naval Hospital, Patio, 1922. The original navy hospital included lush gardens, patios, fountains, and benches. The hospital went though many periods of expansion, especially during wartime. After the attack on Pearl Harbor the hospital dramatically increased capacity in 1942 by annexing all of the exposition buildings, including the California Building as hospital wards, the House of Hospitality as nurses' dormitories, and the House of Pacific Relations as bachelor officers' quarters.

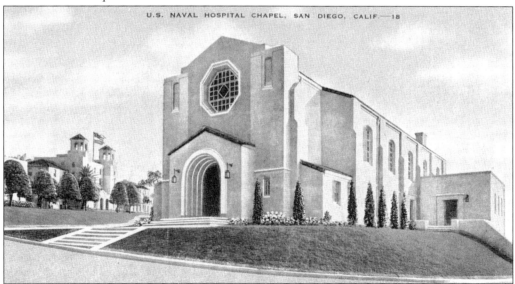

U.S. Naval Hospital, Chapel. This interdenominational chapel was dedicated in 1945, west of the main hospital. The building now serves as the Veterans Museum and Memorial Center to honor the memory of those who served in the armed forces. Exhibits include military artifacts, documents, photographs, memorabilia, and artwork. In 1988, a controversial $257 million replacement Naval Hospital opened in Florida Canyon, north of the original hospital site.

CALIFORNIA WORLD PROGRESS EXPOSITION

This is a

Facts Preview

of the first of
a new cycle of
EXPOSITIONS

The California World Progress Exposition — Century of the Pacific — will be the first in a new cycle of Expositions. It will mean much to every person in San Diego.

The Panama-California Exposition in 1915 and the California Pacific International Exposition in 1935 were tremendous factors in San Diego's growth.

As a result of these Expositions, San Diego has a $30,000,000 facility — Balboa Park — in which to house and stage the 1953 World's Fair.

The California World Progress Exposition in 1953 will mean new income . . . it will bring new money to encourage our economy.

Our Century of the Pacific will attract investments of many millions by exhibitors and add permanent assets to the cultural, business and industrial life of San Diego.

Direct all inquiries to

Clyde M. Vandeburg, Executive Vice President
Administration Building, Balboa Park,
San Diego, California

The California World Progress Exposition will demonstrate a Design for Freedom and Better Living.

CALIFORNIA WORLD PROGRESS EXPOSITION. This is the Balboa Park exposition that never was. Pictured above is a c. 1948 brochure that touted the 1953 California World Progress Exposition. Former newspaperman Clyde M. Vandeburg led the effort to host Balboa Park's third world's exposition. The plans also included activities at Mission Bay Park. The goal of the exposition was to "demonstrate a Design for Freedom and Better Living" and show off "the exciting growth and progress of the West." Vandeburg envisioned several unique additions to Balboa Park, including an International Air Bazaar, a Sports Midway, a California Ranch Home exhibit, and replacing the Ford Building courtyard with an Olympic-sized swimming pool to create a 5,000-seat aquatic coliseum. Lack of public support and the start of the Korean War in 1950 doomed the event. Other failed proposals for Balboa Park included a new Padres ballpark in 1955, a civic theater in 1957, and repeated attempts to replace the exposition buildings with new designs. Thankfully most of the decisions made since 1868 regarding the future of Balboa Park have been good ones.

BIBLIOGRAPHY

Amero, Richard. San Diego Historical Society Web site: http://sandiegohistory.org.

Bokovoy, Matthew F. *The San Diego World's Fairs and Southwestern Memory, 1880–1940.* Albuquerque, NM: University of New Mexico Press, 2005.

California Pacific International Exposition Official Guide, Souvenir Program and Picture Book. San Diego: G. F. Wolcott, 1935.

The Exposition Beautiful—Over One Hundred Views, The Panama-California Exposition. San Diego: Pictorial Publishing Company, 1915.

Fore-Glace at Panama-California Exposition, San Diego 1915. San Diego: King Printing Company, 1911.

Goodhue, Bertram Grosvenor, FAIA (Described by Carleton Monroe Winslow, AIA). *The Architecture and the Gardens of the San Diego Exposition.* San Francisco: Paul Elder and Company, 1916.

Graham, Stanley. *Zoro Gardens—Home of the Nudists* (First Edition). San Diego: 1936.

Ground Breaking Panama-California Exposition, July 19-20-21-22, 1911 Official Program. San Diego: Panama-California Exposition, 1911.

Keystone View Company, Meadville, PA: 1915.

Neuhaus, Eugen. *The San Diego Garden Fair.* San Francisco: Paul Elder and Company, 1916.

The Official Guide Book of the Panama-California Exposition. San Diego: Panama–California Exposition, 1915.

Requa, Richard S., AIA. *Inside Lights on the Building of San Diego's Exposition, 1935.* San Diego: Richard S. Requa, 1937.

Showley, Roger M. *Balboa Park—A Millennium History.* Carlsbad, CA: Heritage Media Group, 1999.

Vandeburg, Clyde M. *California World Progress Exposition, Facts Preview.* San Diego: *c.* 1948.

ACROSS AMERICA, PEOPLE ARE DISCOVERING SOMETHING WONDERFUL. *THEIR HERITAGE.*

Arcadia Publishing is the leading local history publisher in the United States. With more than 3,000 titles in print and hundreds of new titles released every year, Arcadia has extensive specialized experience chronicling the history of communities and celebrating America's hidden stories, bringing to life the people, places, and events from the past. To discover the history of other communities across the nation, please visit:

www.arcadiapublishing.com

Customized search tools allow you to find regional history books about the town where you grew up, the cities where your friends and family live, the town where your parents met, or even that retirement spot you've been dreaming about.